JOHN WATERS
CHANGE OF LIFE

JOHN WATERS
CHANGE OF LIFE

exhibition co-curated by
MARVIN HEIFERMAN AND LISA PHILLIPS

with contributions by
MARVIN HEIFERMAN
GARY INDIANA
LISA PHILLIPS
BRENDA RICHARDSON
TODD SOLONDZ

Harry N. Abrams, Inc., Publishers,
in association with the
New Museum of Contemporary Art, New York

JOHN WATERS: CHANGE OF LIFE

New Museum of Contemporary Art
February 8–April 18, 2004
Co-curated by Marvin Heiferman and Lisa Phillips

The exhibition
JOHN WATERS: CHANGE OF LIFE
is sponsored by New Line Cinema.

Additional support
for *John Waters: Change of Life*
is provided by the
Judith Rothschild Foundation.

The New Museum of Contemporary Art receives general
operating support from the New York State Council
on the Arts, the New York City Department
of Cultural Affairs, JPMorganChase,
the Helena Rubinstein Foundation, and the members
of the New Museum.
The catalogue is also made possible by
the Penny McCall Publication Fund at the New Museum.
Donors to the Penny McCall Publication Fund
are James C. A. and Stephania McClennen,
Jennifer McSweeney, Arthur and Carol Goldberg,
Dorothy O. Mills, and the Mills Family Fund.

Published in 2004 by
Harry N. Abrams, Incorporated, New York

Printed and bound in China
10 9 8 7 6 5 4 3 2 1

Harry N. Abrams, Inc.
100 Fifth Avenue
New York, NY 10011
www.abramsbooks.com

Abrams is a subsidiary of

HALF TITLE
John Waters "Cry-Baby" doll
by Joe Nero
from the personal collection
of John Waters

TITLE PAGE TOP
John Waters's first 16mm movie camera
from the personal collection
of John Waters

TITLE PAGE BOTTOM
John Waters's first 35mm still camera
from the personal collection
of John Waters

PAGE THREE
LIZ TAYLOR'S HAIR AND FEET, 1996
Hair: twenty-six chromogenic prints
Feet: seven chromogenic prints
Checklist #28

RIGHT
SELF-PORTRAIT, 1994
Ten chromogenic prints
Checklist #14

CONTENTS

6
SPONSOR STATEMENT
NEW LINE CINEMA

7
ACKNOWLEDGMENTS
MARVIN HEIFERMAN & LISA PHILLIPS

11
HE HAS SEEN "IT"
LISA PHILLIPS

20
EVERYTHING ALWAYS LOOKS GOOD THROUGH HERE!
JOHN WATERS AND PHOTOGRAPHY
MARVIN HEIFERMAN

52
WATERWORKS
GARY INDIANA

76
LOOKING FOR ART IN ALL THE WRONG PLACES:
JOHN WATERS'S SURROGATE DRAWINGS
BRENDA RICHARDSON

102
INTERVIEW WITH JOHN WATERS
TODD SOLONDZ

125
ANNOTATED CHECKLIST

140
SELECTED EXHIBITION HISTORY, FILMOGRAPHY & BIBLIOGRAPHY

143
NEW MUSEUM TRUSTEES
AND STAFF

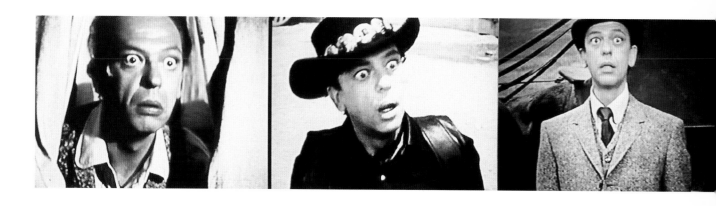

SPONSOR STATEMENT

We are tremendously honored to be a part of the New Museum of Contemporary Art's exhibition *John Waters: Change of Life*. For over thirty years, John Waters has explored the art of filmmaking in a profoundly unique way. With an enduring body of work and a thriving film community in Baltimore, John is living proof that a filmmaker can break any boundary set before him or her, provided he or she does it with style, integrity, and vision.

From *Multiple Maniacs* to *Pink Flamingos* to his breakthrough with *Hairspray*, it has been a singular joy to have played a part in his infiltration of American cinema. John continues to be an important and beloved member of the New Line family, and we are delighted that the New Museum of Contemporary Art has chosen to recognize his influence on popular culture and on contemporary humor with this timely and important exhibition.

From February 8 to April 18, 2004, people from all walks of life will have the opportunity to experience the far-reaching works, influence, and details of John's art. We are proud to work with the New Museum as lead sponsor and hope art, literature, and film lovers will enjoy this rare opportunity to explore the mind of one of the most controversial, influential, and wonderful voices in contemporary art.

Robert Shaye
Co-Chairman and Co-C.E.O
New Line Cinema

Michael Lynne
Co-Chairman and Co-C.E.O
New Line Cinema

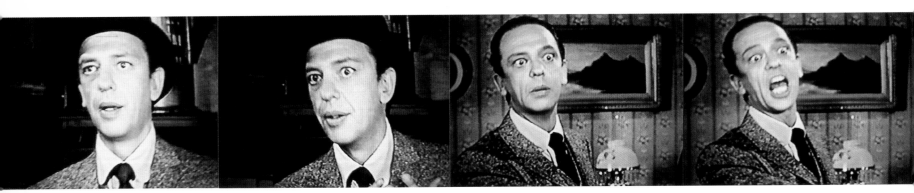

SELF-PORTRAIT

ACKNOWLEDGMENTS

This project has been under discussion and planning for several years. Brenda Richardson initiated the idea for an exhibition of John Waters's photography and brought it to the New Museum's attention several years ago. We are grateful for her ongoing involvement and participation as a contributing author to the book.

Several people made valuable contributions to the research and organization of the project: Leith Johnson and Joan Miller of the Cinema Archives at Wesleyan University, which houses John Waters's archives; Tracey Frey, Susan Allenbach, and Tanner Almon in John Waters's office; Dennis Dermody; Alpesh Patel, Executive Assistant, Director's Office, and Erin Barnett, Joanne Leonhardt Cassullo Curatorial Fellow, at the New Museum; Maurice Berger; Leon Falk; Doug Singsen; and Daniel McDonald, Christine Tsvetanov, and the rest of the staff at American Fine Arts.

All production aspects of both the book and exhibition have been expertly handled by Melanie Franklin, Curatorial Coordinator, and beautifully designed by Lorraine Wild and her associate Stuart Smith. We are most fortunate to have outstanding contributions from Brenda Richardson, Gary Indiana, and Todd Solondz who provide insights into John's work not previously shared with the public. Michelle Piranio's diligent work as editor and proofreader was invaluable during the production of this book. We are also grateful to Eric Himmel, Susan Richmond, and Justine Keefe at Abrams for publishing and distributing the book in conjunction with the exhibition.

The exhibition would not be possible without the extremely generous contribution of New Line Cinema, stalwart supporters of Waters's vision for over three decades. Special thanks to Michael Lynne and Robert Shaye for their support of this project.

In addition, we are most appreciative of support from the Judith Rothschild Foundation.

Our thanks to Vince Peranio, John Waters's longtime production designer, who has designed a vital component of the show that captures the spirit of John's vision and his domestic environment.

Finally, we are most indebted to John Waters, whose vision and insights have informed the whole conception and process of this project.

This book and the exhibition
John Waters: Change of Life
are dedicated to the memory of Colin de Land.

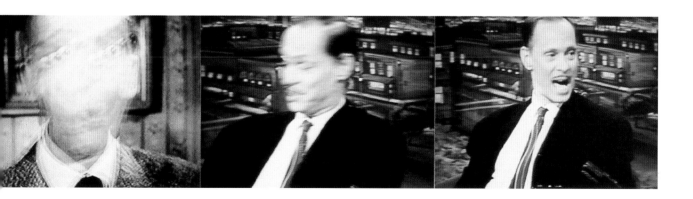

Record covers and a book
from the personal collection
of John Waters

The Baltimore Chronicle

WEATHER Complete New York Stocks Full Coverage Sports Events FINAL EDITION

Foot Stomper Released -- Insanity

Board Waives
Hearing For Two
University Teachers

House Plans
Program to
Fight Crime

Face-Lifting
Job to Start
On City Hall

STATE ASSEMBLY APPROVES

Education Bill Met With Overwhelming Support

TOP
Prop from *Polyester*, fictitious
front page of *The Baltimore
Chronicle*. From the personal
collection of John Waters
BOTTOM
Magazine and newspaper
from the personal collection
of John Waters

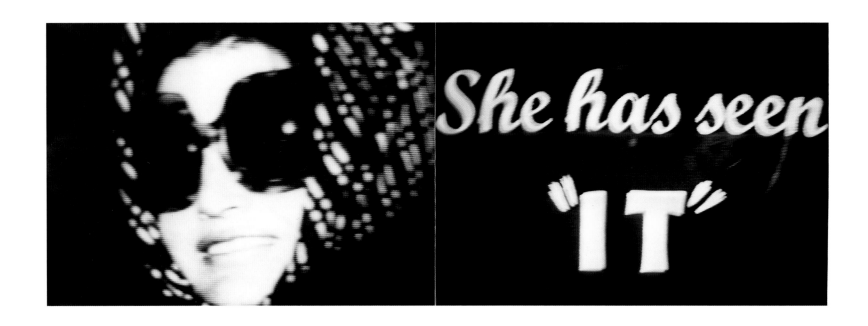

IT, 2000
Two chromogenic prints
Checklist #55

HE HAS SEEN "IT"

Lisa Phillips

What does John Waters dream about? The Wicked Witch of the West? Jesus Christ? Dorothy Malone's collar? Russ Meyer? True Crime? Sex Addiction? Art?

Waters's world is a special place of his own creation—a zany, anarchic, darkly humorous vision of America where nonconformity is taken to new extremes, hierarchies are overthrown, and taste-lessness is embraced with abandon. Over a career spanning four decades, Waters has plied his offbeat personal aesthetic through filmmaking, photography, writing, and performing. At first he operated on the margins as an underground figure, but during the course of forty years he has become a cult hero. And now, with the musical *Hairspray* appearing on Broadway to great acclaim, he threatens to become a mainstream institution.

With the 8mm Brownie that his grandmother gave him for his seventeenth birthday and some shoplifted film, Waters made his first movie, *Hag in a Black Leather Jacket* (1964), while still in high school. Two years later, when he was asked to leave NYU for smoking marijuana, he already had the ambition, the drive, and the courage to take on a wholesale reevaluation of American Family Values. By the time he was twenty-seven, he had written, directed, and produced eight films, including the cult classics *Pink Flamingos* (1972) and *Female Trouble* (1974). After becoming a major force in the independent film movement with his extremely subversive films, Waters's audience grew (as did the movement) and he was finally given the opportunity to work within the Hollywood system writing and directing films such as *Hairspray* (1988) and *Serial Mom* (1994). In the early 1990s, while continuing to make films, Waters also took up photography with great passion, creating works that he dubbed his "little movies." Mostly elaborate sequential compositions of pictures from movies taken off his TV set, these photographs expand on his film work while standing alone as a body of work. They also point to Waters's roots in art and the underground—where figures such as Andy Warhol and Robert Rauschenberg moved fluidly back and forth between media.

Waters's journey from margins to mainstream has been a fascinating trajectory; in the process he has continually challenged preconceived values and helped to transform societal attitudes. It's a journey that could only have happened in late twentieth-century America, with its profound social

upheavals and transformations. Who would have imagined that the "Sultan of Sleaze" would end up a national cultural treasure? The irony of the situation is not lost on Waters: "I was nervous only once, when the Baltimore Museum of Art gave me a three-day retrospective of films in 1985. Somehow I was suddenly respectable. It was as if magically, the films had changed content in the cans over the years. Here I was being honored for work I had feared being imprisoned for a decade before."[1] Things that created shock waves in the 1960s now seem sedate compared to the real-life confessions on day-time talk shows and reality television claiming primetime attention today. But Waters has doggedly pursued his vision from the beginning, working on the edge as a prophet and a tastemaker, devel-oping his art as a photographer and a filmmaker, and earning himself a place in the pantheon of true American iconoclasts.

Whatever medium he chooses to work in, Waters always spins a consistent world view, relent-lessly questioning notions of what is "normal" and what is "different," what is "good" and what is "bad." Scandal, sleaze, tastelessness, and celebrity are the prime ingredients of Waters's artistic time bombs, which release rage and anger through black humor. His outsider subjects confront the hypocrisy and the cruelty of daily life—their oppression and despair at being fat, gay, outlaws, freaks, or failures—with humor.

Waters's sensibility was already evident even in early childhood. As a young boy, he was drawn to the violent fantasies in fairy tales—the evil Queen in *Snow White and the Seven Dwarfs* and Captain Hook in *Peter Pan* were his favorite characters, the ones he related to. He staged disasters and car wrecks with toys, and found scary/funny figures like Clarabelle the Clown from *The Howdy Doody Show* particularly appealing. According to Waters, when he was seven, his fate was sealed when his parents took him to *The Howdy Doody Show* in New York City. There, he saw how they used multiple Howdy Doody puppets and many cameras to produce the show. Waters was thrilled by "the lie of it all," by the underlying artifice. Soon he was back home in Baltimore making serious pocket change by creating his own crazy puppet shows full of mischievous antics for the neighbor-hood kids.

As he evolved from puppet shows to live-action films shot in and around his parents' Baltimore home, his creative vision began to take hold. Increasingly attracted to low-life outcasts, freaks, and weirdoes, by 1967 Waters had assembled a ragtag group of friends and eccentrics that included cross-dressers, shoplifters, and drug users. They formed Dreamland Studios—the film and repertory com-pany that provided the foundation for Waters's subsequent films, from *Mondo Trasho* (1969) to *Hairspray*. The company included Mink Stole, Mary Vivian Pearce, David Lochary, and Waters's muse, Glenn Milstead (Divine), who just so happened to be the "girl" next door (he lived six doors down from Waters when they were in high school).

Moving back and forth between Baltimore, New York, and Provincetown, Massachusetts, during the 1960s, Waters frequented vanguard galleries, fringe clubs, and counterculture bookstores. He

14

took in the work of Andy Warhol, the Kuchar brothers, and Kenneth Anger, and read *Film Culture,* *Evergreen Review,* and everything published by Grove Press. He was coming of age in a particularly fertile period of political and social ferment when conventional values were all up for question, alternatives were continually being proposed, and various liberation movements proliferated. The line between high and low art was eroding as new complexities arose that rendered old binary oppositions passé. In these watershed years, Waters emerged as a true American original. Like so many disaffected adolescents, he dropped out of school, took drugs, and made a virtue of being different. But he had a particular genius for turning that virtue into the substance of his art.

Whether making puppet shows, films, or photographs, Waters invariably directs and redirects material from daily life to create dramas that refocus our attention on his particular loves and obsessions, fears and loathings. The media is a principal obsession (he subscribes to 118 magazines) and he carefully collects material from real-life sources—particularly lurid tabloids such as the *National Enquirer* and the *Globe*. Clippings, headlines, ads, and film stills assembled in scrapbooks and on elaborate bulletin boards form the underpinning of much of his art. His fanatical observation of daily life plays into his brilliant satirical vision: he is unsparing in his rants against everything from fashion victims, walkathoners, gentrification, vegetarianism, and liberal attitudes to the U.S. mail service, pro-lifers, hippies, computer gamers, and boring film classics. And, he holds a special loathing for middle-of-the-roaders. On the other hand, he is equally passionate in his love of books, novelties, jokes, oddities, hairdos, adult comics, religious paraphernalia, and notorious media personalities. His library, which he loves to arrange, features titles in the areas of extreme weather, psychological illness, sex, Nazis, Catholicism before the Reformation, and high society. His early photographs are mostly serial collages of pictures he (re)takes directly off the TV set of his favorite films, including *Boom, Peyton Place,* and *The Bad Seed*.

Waters's auteurism has a particular focus around the subjects he loves and hates. His consistent preoccupation with fame, perversions, religious fanaticism, crime, and abjection (vomit, garbage, assholes) are all pressed into service of the larger themes of class distinction, race relations, suburbia, the family unit, and sexual preference. The dangerous, the dirty, the naughty (he loves puke green and rats), the weird, the filthy, and the flagrantly erotic bump up against upper-middle-class refinements in combustible juxtapositions. (Waters has a series of Cy Twombly prints hanging in his dining room and a Gregory Greene bomb factory installation in his attic.) Commonly held assumptions about what is "normal" or "good" are reshaped by his carnivalesque and camp vision. Waters questions and lampoons social mores and standards of "normality" at every turn—in the films through the unsophisticated yet authentic viewpoints of Baltimore's working class and low life. His protagonists' stubborn adherence to unpretentious, honest, and somewhat righteous attitudes is a send-up of high culture linking Waters to other brilliant social satirists of his generation such as Matt Groening (*The Simpsons*) and Roseanne Barr, whose poignant depictions of the working class in America have struck a popular chord.

Waters has mixed and matched, cross-dressed, exchanged, and mutated the foundations of our values in both obvious and subtle ways. In his photographs he has overlaid the wicked witch with the good witch of Oz; cast Charles Manson in a number of look-a-like scenarios (Manson copying Brad Pitt, Richard Gere, etc.); titled a figurine of Jackie Kennedy *Jackie Copies Divine's Look* (2001); and in his early film *Eat Your Makeup* (1967), he cast Divine as Jackie Kennedy in a remake of the Zapruder film. Waters questions what is real and what is fiction. How close do we all come to being sinister and criminal? How are criminals and stars alike treated as celebrities by the media? Is there beauty in the ugly, the obvious, or the unnoticed? In his world view, everything can be seen as containing the *potential* for its opposite.

The constant reversal of roles and value systems in Waters's art extends to his formal values as well—in particular, his love of "bad form," "bad photography," and "bad filmmaking." He has made a virtue of the bad or the failed, using techniques considered by most to be "crass," "tasteless," or "gimmicky"—Odorama, cheap effects, jumpy camera movements. He has further commemorated these principles in his photographs with works such as *Despair* (1995), where frames credit Alan Smithee, the pseudonym used by the Director's Guild of America when a director has removed his name from a film; *Straight to Video* (2000), implying that a film is so bad it will never be theatrically released; and *Hair in the Gate* (2003).

In *It* (2000), Waters photographed a picture of Jackie Kennedy and paired it with a frame that reads: "She Has Seen 'IT'." What is "IT"?—Camelot, privilege, power? Blood, death, misery? The dream, the nightmare, the god, the monster, the lie, the truth? Waters has also seen "it." He's seen how the media has perpetrated a mythic ideal of the family, of political dominance, of the miracles of consumption—and how it also loves the dark side—the rampant pathologies, the fascination with obesity, mass murder, celebrity misfortune, and other tragedies. As a true visionary, Waters has seen the seamless image and the cracks in it; he understands the need for artifice and the need for it to serve a higher purpose.

[1]John Waters, *Crackpot: The Obsessions of John Waters* (New York: Macmillan Publishing Company, 1986), 75.

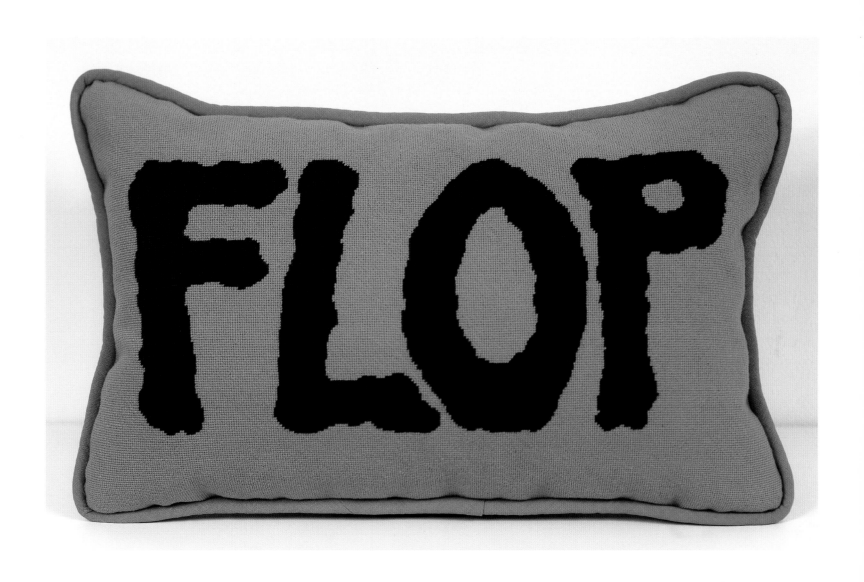

FLOP, 2003
Needlepoint pillow on pedestal
Checklist #80

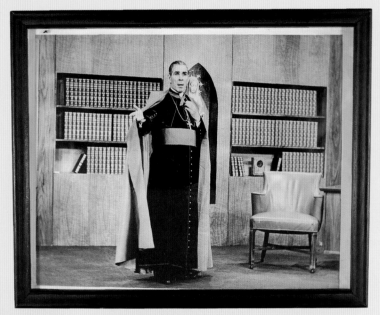

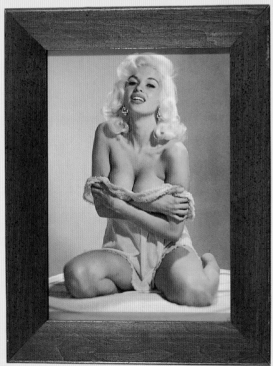

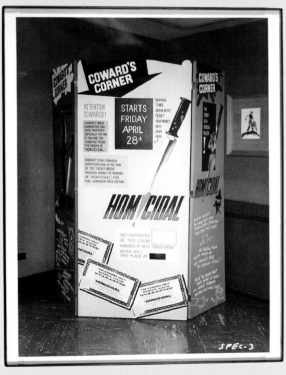

TOP
Publicity photograph of Bishop
Fulton J. Sheen from the
personal collection of John Waters

BOTTOM LEFT
Publicity photograph of Jayne
Mansfield from the personal
collection of John Waters

BOTTOM RIGHT
Photograph of "Coward's Corner"
publicity gimmick for William
Castle's film, *Homicidal* (1961),
from the personal collection
of John Waters

EVERYTHING ALWAYS LOOKS GOOD THROUGH HERE!

JOHN WATERS AND PHOTOGRAPHY

Marvin Heiferman

John Waters's *Pecker* (1998) is a coming-of-age film about an artist who can't stop himself from taking pictures. "Man, everything always looks good through here!" Pecker exclaims, squinting through his viewfinder, and it does. Like most photographers, Pecker is an outsider who looks at the world as it presents itself to him, and then reshapes and reorganizes it in pictures. He photographs everything that confronts, confounds, and delights him. In the basement darkroom of his family's home, sweetly peculiar images emerge on sheets of paper in Pecker's developing trays: an intent and narcissistic woman shaving her legs on the bus; melting cheese slices merging with greasy meat on the grill at the Sub Pit, where he works; rats humping in the garbage; go-go boys rubbing their briefs-covered crotches across the foreheads of the patrons of the Fudge Palace, the gay bar where Pecker's sister Tina is employed as a barmaid and barker.

"You see art when there's nuthin' there," Pecker's girlfriend, Shelley, tells him. And because he does, and through the spiral of events that propel the film's plot, New York art world insiders anoint Pecker the next big star. A paunchy and closeted *New York Times* art critic finds Pecker to be "a humane Diane Arbus, with a wonderful streak of kindness" and glowingly reviews his

first gallery show. Demand and prices for his technically deficient but charming black-and-white photographs escalate. First the art press hypes Pecker's talent, then the media appropriates his images and persona to serve its own needs. Pecker lands a cover of *Artforum*, is featured on MTV, and is photographed by Greg Gorman for a big spread in *Vogue*.

But Pecker's success starts to backfire as soon as it registers back home, after *The Baltimore Sun* honors its native son's rise to superstardom for taking "delicious photographs of his culturally challenged family." His family's house is robbed. His girlfriend is insecure and grows jealous. And soon Pecker is confronted with the biggest dilemma of his short life. The Whitney Museum, arbiter of hipness, wants to mount *A Peek at Pecker*, a one-person show of Pecker's oeuvre. If he continues to accept the acclaim and cash that come from servicing the art world's aesthetic, commercial, social, and even sexual demands, Pecker will have to exploit his own vision and loved ones. He'll be pressured to portray his everyday Baltimore world not as a wondrous place but as a freak show. If he declines, his career may be over.

A quintessential good boy, Pecker summons up the courage to just say no. With the pile of money he's made from the sale of limited-edition prints, he opens a bar, Pecker's Place, and dec-

TOP
Fictitious Whitney Museum of American Art catalogue used for Japanese publicity of *Pecker* (1998) from the personal collection of John Waters

BOTTOM LEFT
Still from *Pecker*, 1998, featuring Edward Furlong as Pecker

BOTTOM RIGHT
Still from *Pecker*, 1998, featuring Cindy Sherman, as herself, in a cameo with a fictitious Whitney Museum curator, Scott Morgan, at Pecker's first gallery show

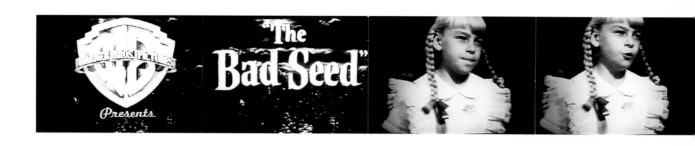

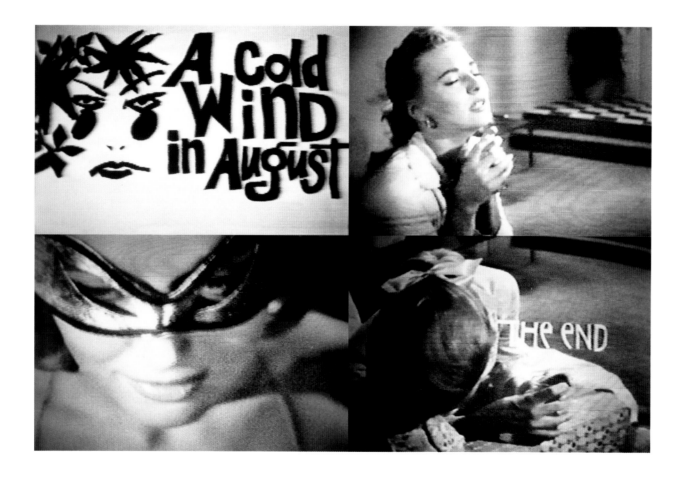

TOP
BAD SEED, 1994
Nine chromogenic prints
Checklist #8

BOTTOM
A COLD WIND, 1992
Four chromogenic prints
Checklist #1

orates it with portraits of art world insiders, whose stylish and urban brand of freakishness entertains the locals. On opening night, a chartered busload of "Friends of the Whitney"—over-zealous collectors, curators, and critics tantalized by Pecker's professional aloofness—descends on the scene. On the walls, the slumming trend-sniffers see themselves represented in Pecker's latest work and, facing evidence of their own outsider status, register confusion and discomfort. But soon their sense of "otherness" lifts, as the thrill of their proximity to what they believe to be avant-garde, the flow of liquor, and a gradual unleashing of libido take over. Because Pecker is now a celebrity, the media is on hand and ready to capture the now-rau-cous scene. In the closing moments of the film, a TV reporter queries, "What's next, Pecker?" And instead of the warm and fuzzy response he expects, the reporter gets a surprise: "You know what?" says Pecker, considering how photography has altered his life and where it might yet lead him, "I'm thinking of directing a movie."

The idiosyncratic originality of an outsider's vision and the transformative powers of photography, two themes that propel the plot of *Pecker*, also help to explain how and why John Waters, filmmaker, came to be known as John Waters, artist. While *Pecker* can't accurately be called an autobiographical movie, certain similarities between its main character and its filmmaker are undeniable. Both use the freedom that comes

from living and working in Baltimore to great effect; they see the world enthusiastically and obliquely. And just as Pecker embraced photography as a way to make sense of his experi-ence, so, over the past ten years, has Waters. In his photographic works he reflects on remembrances of films past and on his involvement in the film world, and in that process raises some provocative and useful questions about the transformative power of movies and of photographic fictions.

"There are no second acts in American lives," a despondent F. Scott Fitzgerald wrote in the working notes for *The Last Tycoon*, toward the end of the Great Depression. Today, that much-quoted line no longer carries either the sadness or the truth it did in the wake of the Depression. For Americans born in the second half of the twentieth century, the reinvention of self is something taken for granted, just one more of our inalienable rights. A recent case in point is America's infatuation with real-ity television programming—shows such as *Joe Millionaire*, *Queer Eye for the Straight Guy*, and *Extreme Makeover*, where self-loathing sad sacks are transfigured by plastic sur-geons, worked over by stylists, and sent home in white stretch limos. Promises of transformation drive America's consumer and popular-culture fantasies; they fuel our spiritual searches, addictions, and art. We believe that the narrative of our lives, all narratives in fact, are malleable, as subject to our changing whims and willfulness as to fate itself.

RIGHT
Prop photographs from
Pecker, 1998, included in
Pecker's exhibition at the
Sub Pit sandwich shop
in Baltimore

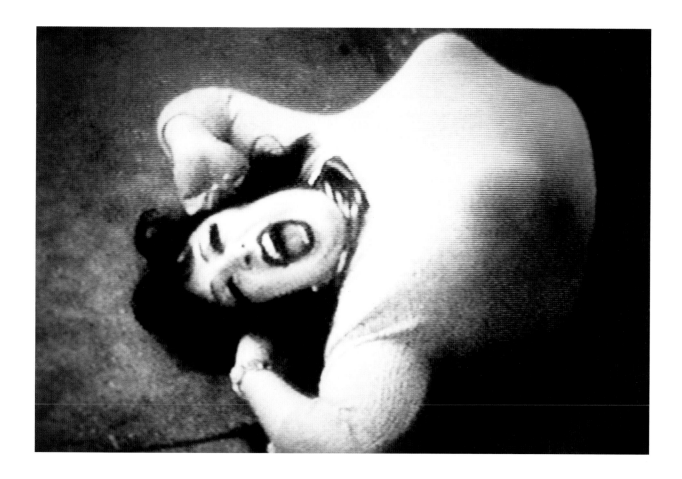

TOP
SLADE 16, 1992
Sixteen chromogenic prints
Checklist #4

BOTTOM
DIVINE IN ECSTASY, 1992
Chromogenic print
Checklist #2

The sense of relativism that characterizes so much of contemporary experience helps to explain why Waters's first exhibition of artworks in 1995 elicited curiosity, but not shock. On display were intriguing works, most of them collages of snapshot-sized color prints that were clearly shot off a television screen.

In trying to trace the genesis of his first "serious" photograph, Waters recalls receiving a request for a specific film still from *Multiple Maniacs* (1970). And though he vividly "remembered Divine's face in the one moment between rape and miraculous intervention where he lived up to the spiritual side of his

SLADE 16

Some were presented as individual prints, some as diptychs, some in grids, but most were arranged side by side like neat, horizontal filmstrips. Each told a highly distilled and stylized story. In *A Cold Wind* (1992), Waters boiled the entirety of an arty, black-and-white movie he saw in Baltimore down to four cryptic frames—the movie's title, a woman in prayer, then wearing a naughty-looking mask and then again, collapsed on a pillow—a sort of CliffsNotes version of the downward spiral of a party girl's life. In *Bad Seed* (1994), Waters revisited the 1956 film that mesmerized him as a child, focusing adult attention on the face of child actress Patty McCormack, who portrayed the fastidious, tightly wound little murderess, Rhoda Penmark, in a scene where, in one delicious frame after another, her face seethes with anger, evil, malevolence, and gorgonlike fury.

Waters did not set out to reinvent himself as a gallery artist. Early in his career, his iconoclastic and low-budget movies secured for him a loyal audience and a place in cinema history. In the 1990s, however, as noted by critic Manuel Vidal Estévez, Waters was faced with growing international success, the death of Divine (the riveting drag queen and brilliant star of many of his films), and the delays, compromises, and restrictions that came with industry financing and distribution of his bigger-budgeted projects.[1] Given the nerve-wracking, provisional nature of a filmmaker's life, and Waters's own perpetual state of intellectual and creative overdrive, it is not surprising that he would move forward with short-term, smaller-scaled projects he could keep under his own control.

name,"[2] there was no photograph of it. So Waters decided to make the film still himself. Planted in front of a television, scrutinizing a videotape of the film with a small, automatic point-and-shoot 35mm camera in his hand, the search began. "I took hundreds of shots off the TV monitor, blundering my way into photography the same way I blundered into films, until I finally produced what I wanted."[3] The result, *Divine in Ecstasy* (1992), is hilarious and harrowing. Divine is shot from above and seen on his back, flesh barely contained by a vixenish, too-tight sweater, arms raised to his head like a bawling baby, and with a scream contorting his face that channels the most egregious of Joan Crawford's scenery-chewing, late performances in horror movies.

The process so intrigued Waters that he continued to shoot stills off the television from videotapes of other movies he wanted to remember, including *Susan Slade* (1961), an arch and lushly produced melodrama. Starring Connie Stevens and Troy Donahue, the plot revolved around young love, an unwanted pregnancy, family dysfunction, and tragedy. But again, what Waters remembered and wanted to see again was very specific, the plot turn and image that had preoccupied him as a child: "I only cared about the scene where the baby caught on fire, which…really stunned my twelve-year-old morals. I wanted to have a reminder of that moment, that experience, that film…a picture of it….The only way I could do it was to try to find the movie and make it for myself."[4] Waters edited the stacks of processed drugstore prints of images he'd captured from the

screen down to the ones he liked best. *Slade 16* (1992) is Waters's first photographic sequence, the recovered memory of his preteen film experience that weaves together images of lust, spirituality, a warning shot of a baby's tiny outstretched hand straining to reach a silver cigarette lighter, and a burst of flames.

of the famous photo of the Indianapolis 500 tragedy that I had secretly clipped and hidden under my bed."[6]

As a young teenager, Waters became a sought-after entertainer in Baltimore. A puppeteer-for-hire who performed at children's birthday parties, he profited nicely from his Punch and

It looks like the coming attractions for something that, in fact, happened a long, long time ago.

Over the next two years, and in secret, Waters made more photographic sequences of stills—extracted from his own movies, and even more willfully, from those made by others—that were essential for the stories he wanted to see, remember, and tell to himself. No financing, no producers, no crews, no distribution deals, no compromises necessary.

This need to fashion and refashion narratives evolved early in Waters's life. "My parents claim they suspected something was wrong with me from the beginning, and my childhood obsession with car accidents seemed to confirm their worst fears. While other kids were out playing cowboys and Indians, I was lost in fantasies of crunching metal and people screaming for help." Waters would manipulate relatives into buying him toy cars, and then he'd use them to stage mock accidents. "I would become quite excited and start smashing the car with a hammer, all the while shouting, 'Oh, my God, there's been a terrible accident!'"[5]

Waters's flair for scripting drama was further influenced by his exposure to photographic images in the media, as evidenced by his musings as a child when he dutifully but unhappily accompanied his father to sporting events. "I would be disappointed to see that the players actually wore special costumes designed to protect them from injury. I noticed ambulances waiting on the side of the field, so what was the big danger? Bored to tears, I fantasized the stadium bleachers collapsing, all the while thinking

Judy shows, until their rising levels of violence and stage blood brought him notoriety and caused bookings to taper off precipitously. In high school, Waters authored short plays reflecting his fascination with the fractured narratives of the Theatre of the Absurd and the plays of Eugene Ionesco, Samuel Beckett, and Edward Albee. By the mid-1960s, Waters was hitchhiking to New York where he immersed himself in the underground films—Andy Warhol's *Blow Job* and *Empire*, Kenneth Anger's *Scorpio Rising*, Jack Smith's *Flaming Creatures*, George and Mike Kuchar's *Hold Me While I'm Naked* and *Sins of the Fleshapoids*—that would influence his own first elliptically narrative films.

Emboldened by the exuberance, drugs, and counterculture values of the time, Waters brought together a group of friends and acquaintances and ran Dreamland Studios out of his bedroom in his parents' home. With the Brownie 8mm movie camera his grandmother gave him for his seventeenth birthday, and film a friend shoplifted for him, Waters shot his first short movie, *Hag in a Black Leather Jacket* in 1964, followed by *Roman Candles* in 1966 and *Eat Your Makeup* in 1967, which were shown locally, often in Baltimore churches. The full-length films he made next—*Mondo Trasho* (1969), *Multiple Maniacs*, *Pink Flamingos* (1972), *Female Trouble* (1974), and *Desperate Living* (1977)—brought him a national audience, success, cult status, and notoriety. He was showered with epithets: "King of Kink," "Sultan of Sleaze," "Pope of Trash," "Prince of Puke," "Anal Ambassador."

Poking holes through conventional morality and behaviors became a challenge of a different sort once Waters graduated from the midnight-movie circuit to make bigger-budgeted studio movies. In *Polyester* (1981) he cleverly figured out how to make a film that was simultaneously twisted and relentlessly cheery.

Waters has acknowledged the effects of maturity on his behavior and on his work as well. "Brigid Berlin, the best of the Warhol superstars…commented to me, 'How can you be "bad" in your fifties?' and she's dead right—you can't. Taking drugs when you're young *can* be mind expanding if it doesn't kill you,

SLADE 16

Waters's comedy *Hairspray* (1988), a buoyant, PG-rated movie that nonetheless grappled with volatile issues of class and racism, went into wide distribution, even as conservative groups were ramping up attacks on much more solemnly provocative art, such as the photographs of Robert Mapplethorpe and Andres Serrano.

By the 1990s, it was time to switch gears. The raucous, uncircumscribed behaviors that distinguished the characters in Waters's movies were rapidly being appropriated by the mainstream as the decibel level of trash-talk on daytime television spiked, foul-mouthed cartoon characters became cultural icons, and cable TV channels proliferated. As Waters recently commented, "I don't think there's anything that's trash anymore…The golden age of trash has long been over because irony ruined it."[7]

but if you're still doing it in mid-career it's called addiction.…Being insane when you're young is sexy; insane at fifty is pitiful.…I'm glad I got to be bad when I was young."[8]

When he began working on his photographic collages in the early 1990s, Waters was already a familiar presence in the New York art scene. With his highly cultivated and recognizable appearance, his frequent visits to New York galleries and the seriousness of his interest in art were duly noted. Colin de Land, a renegade and gifted dealer whose gallery and artists Waters was particularly interested in, once asked the filmmaker if he ever made paintings. Waters said no, but mentioned the photographic project he had underway in Baltimore at the time. Not long after a studio visit from de Land, the first of Waters's exibitions, *My Little Movies*, opened at American Fine Arts.

RIGHT
Handbill advertising John Waters's *Roman Candles* (1966) from the personal collection of John Waters

FAR RIGHT
Photograph of John Waters behind the camera from Steve Yeager's documentary *Divine Trash* (1998)

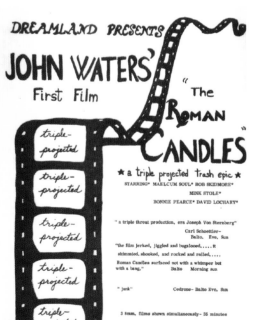

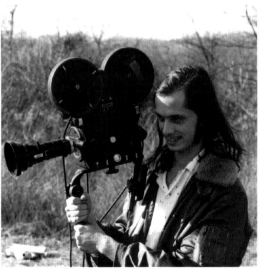

The contemporary art world feels comfortable to Waters; it is a close-knit community of cultural outsiders, a community predisposed to appreciating, discussing, and arguing about the complex forms images take and the meanings they have. "I always tell artists how lucky they are because in their world, if it plays in Peoria it's bad, whereas in the movie world, you have to please everybody....No one in the art world says 'dumb it up.'"[9] For Waters, that was a relief; his photographic interests are complex. He's drawn to rephotographing movie images as a way to explore the gray areas between fact and fiction, between still and moving images. He's interested in using photography to document the malleability of images, language, and memory. His photographic project is dependent upon the process of re-vision, of looking at images again, repeatedly and carefully, to see what new readings and narratives can be coaxed out of them.

Ideas for new pieces usually come first, and tend to be concise, like the "high concept" ideas Waters pitches in the film world. "I'm a writer. Before I ever sell a movie, I do a treatment, which means I have to be able to tell the movie, very quickly, in a couple of sentences."[10] How did Hollywood depict sex when it couldn't show it? In *Peyton Place—The Movie* (1993), Waters presents cut-away shots of pretty scenery, of nature at work, which stood in for the numerous sex acts that couldn't be shown on-screen in 1957. How far will actors go to make their performances look and feel authentic? *Toilet Training* (2000) shows eight thespians on toilet bowls, and *Mental* (1998) presents the overly sincere histrionics of actors out to prove the depth of their empathy and authenticity. What three words terrify a film director the most? The three little words that sound the death knell for feature films so bad they'll never be released in theaters are the sole content of Waters's single-image work *Straight to Video* (2000).

With a concept in mind, Waters researches and secures videotapes of films he suspects will yield up what he wants to see,

and then his decidedly low-tech photographic process begins. A videotape is played, and when Waters gets to the moment in a scene that intrigues him, he snaps a picture. If he senses that he hasn't gotten what he wants, he hits the rewind button and waits for his target to appear again. "The way I photograph…in many ways it's directed by chance and all my mistakes, which often are the best stuff. I found that no matter if it's the same tape, the same TV, and the same camera, I can never duplicate an image…your arm jiggles, there's just too much chance. And I never put it on pause, or use any of that fancy equipment."[11]

The pictures he makes have an odd beauty about them. Instead of the crisp pictures that 35mm film delivers, Waters's images have already been degraded through two previous rounds of photographic translation: from film to television, and from television to snapshot. They're grainy and pixilated. Some look like tapestries that have been woven with the elegantly striated scanning lines that Waters's camera reads off the television screen. Individual frames—photographed from videotapes of wide-screen movies radically cropped to fit the squarish format of television screens—have a compressed, jewel-like quality about them. Waters's works call to mind the children's game "telephone," where one player makes up and quickly whispers a phrase or a sentence to another child, who then whispers what they think they've heard to the next player, and so on, and so on. The original message is altered, sometimes hysterically so, in the process of being retold. Waters's images have a similar character; they purport to reiterate the plot of a movie, or to make a point about a celebrity or a phenomenon, but somewhere in the process of capturing and presenting the images, logic and meaning shift.

To a large extent, what Waters does and what the work is about is editing—the transformation of his source materials into newer fictions that are more critical and useful for the artist. "My

PEYTON PLACE—THE MOVIE, 1993
Sixteen chromogenic prints
Checklist #7

photographs are not really about photography. They are about editing. I use photography but they are all taken from the TV screen. Anybody can do that, but it's the order I put the pictures in to try to create a new kind of movie, something that you can put on your wall."[12] Although a few works consist of single images, Waters's primary interest is in making unconventional narratives, what he calls his "little movies," each one "a new object, somewhere between cinema and photography: border-line objects, both autonomous and dependent."[13] In early works, all the images tended to be extracted from a single movie. Later, images appropriated from various filmic sources were combined around a singular theme or concept in seemingly seamless sequences (for example, *Puke in the Cinema*, 1998).

The process of editing and recontextualizing images is what compels Waters. "Now I watch movies for two different reasons: I watch movies as a film director and I watch movies as an art police officer…looking for details that I can pull out of the movie and put with some other detail from another movie and turn it into a whole different story."[14] His goal is to get viewers "to…see the reverse beauty of some of these movies that are generally thought of in a negative way."[15] "By defacing, removing and severely editing the failed moments of my own work and the under-praised work of others," Waters explains, "maybe we can look at films that were initially dismissed or despised in a more optimistic way."[16]

In the process of rephotographing and reediting movies, images that were ungraspable when projected and experienced at cinematic speed command attention once they've been transformed into still photographs. In *Grace Kelly's Elbows* (1998), eight prints isolate incidental moments from films in which the actress's exquisitely shaped and bent arms can be admired obsessively and unhurriedly outside of movie time. Waters's "little movies" sometimes speed things up as well, often tele-graphically so. He's well aware of the challenge artists face in a visual culture that fosters distraction, impatience, and highly selective vision. "All movies are too long.…Twenty-four frames a second is really overkill. Let's go back and reduce all movies to just the good parts."[17] In *Wicked Glinda* (2003), more than one hundred minutes of *The Wizard of Oz* are reduced to a sin-gle frame, halfway into a dissolve where the face of Margaret Hamilton, the Wicked Witch of the West, merges with that of Billie Burke, who played the Good Witch Glinda.

Disdainful of expensive special effects in movies, Waters uses camera shakes to create cheap special effects in his artwork. He uses sequential photography to speed up, slow down, or alter the construction or progression of narratives. Sequences can be arranged chronologically, as they are in *Leader* (1995), in which frames from the film leader that precedes a feature film seem to tick away the seconds before a movie begins. They can be struc-tured on comparative relationships (see the split-screen juxta-position of Julia Roberts's toothy grin with a hideously disfigured face from a horror film in *Julia*, 2000). The elasticity of linguis-tics is at the heart of *Seven Marys* (1996), in which six images of the mother of Jesus are contrasted with one of Paul Lynde, whose flamboyantly gay TV personality made him a memorable presence on *Hollywood Squares*. Waters tracks a performer's association with a single sartorial quirk in *Dorothy Malone's Collar* (1996) to illuminate how the auras of stars are built from small, but beguiling details.

The ability to identify individual images within the sequences and the interpretation of individual works depend entirely on a viewer's familiarity with Waters's source materials. If you are roughly the same age as the artist and/or share his erudite and quirky cinematic taste, you may be able to pinpoint the movies from which the images were extracted. If not, Waters peppers the pieces with text—such as movie credits announcing the names of films, stars, directors, and producers—and titles the works in ways that provide clues about what he's looking at and what he's

PEYTON PLACE—THE MOVIE

WICKED GLINDA, 2003
Chromogenic print
Checklist #75

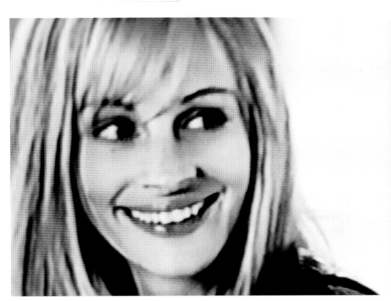

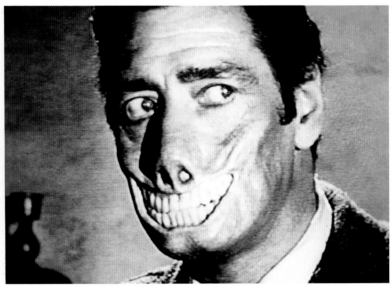

PEYTON PLACE—THE MOVIE

TOP
JULIA, 2000
Two chromogenic prints
Checklist #56

RIGHT
GRACE KELLY'S ELBOWS, 1998
Eight chromogenic prints
Checklist #37

looking for. The goal is for viewers to bring their own idiosyncratic emotional and intellectual baggage to the work, just as we do to the movies, and to daily life.

Waters's images attract us with their seductive content and premeditated presentation. In addition, the inherent characteristics of film stills themselves contribute toward drawing viewers in. Roland Barthes identified various aspects of our complex relationship to photographs that help explain how Waters's works affect the viewer. In trying to understand what makes film stills compelling, but different from film, Barthes noted that "the basic center of gravity is transferred to inside the fragment."[18] When we look at film stills, we are freed from the constraints of our normal, fleeting encounters with filmic images and can read the content of a still image that's been extracted from a movie on multiple levels. If the narrative and chronological thrust of movie narratives seems to push us along horizontally toward the movie's ending, when we look at film stills, we can respond to individual images in a manner that Barthes characterizes as being vertical.

In Waters's work, we can slow ourselves down and feel free to explore whatever potential narrative any of his images, or

for an extra beat, so the men in the audience could get a good look at her ass.

Waters's work reflects the ways in which motion pictures and still images overlap, diverge, and grab hold of our imagination. His video stills encourage us not only to question how movie stories are told but, even more critically, to become more conscious of what it is in them that we find ourselves responding to. And once we do, Waters urges us to follow his lead, to step outside our role as passive audience members and become image liberators ourselves:

> Erase the original auteurs from your faded, scratched, poorly scanned video collection by "writing" with photography. Pretend you're a renegade head of a Hollywood studio with damaged dreams and edit someone else's movie with a reckless disregard for the mainstream. Isolate the out-of-context story points and celebrate the terror of juxtaposition. Mix innocent images of beauty and horror to demystify stars' highly controlled self-images. Thrill to Oscar-baiting "brave roles" that look so silly yet lovely isolated from hype. Celebrate your own

series of film stills, might encode and suggest to us.[19] The assortment of stills in *Lana Backwards* (1994), showing the mid-century film siren Lana Turner standing in or walking through rooms or doorways, seems to lack a narrative thread that would hold them together. But very quickly, multiple meanings pile up. Lana Turner: sweater girl; *femme fatale*; mediocre but inexplicably enigmatic actress; elegant and coarse; lover of mobster Johnnie Stompanato and mother of Cheryl Crane who stabbed him to death; the woman who, Waters firmly believes, was always filmed from behind, in images held

> inflated, self-important movie taste by glorifying movies that were not even remembered for being bad, much less good.
>
> Worship patterns of abuse so strong that they beg to be blown up, cut out, and hung on the wall like taxidermy…Watching a movie should be like hunting. Out of context, every image of the cinema is yours for a split second. Take it before they bury it. Then these pitiful new "movies" made up from the scraps of others won't be anybody else's but your own.[20]

GRACE KELLY'S ELBOWS

TOP
MENTAL, 1998
Nine chromogenic prints
Checklist #43

RIGHT BOTTOM
LEADER, 1995
Eight gelatin silver prints
Checklist #19

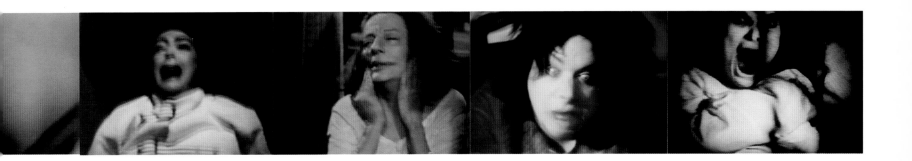

As this mock manifesto suggests and the work reveals, Waters is more excited by subject matter than by rarified formal issues. He quickly left New York University upon the urging of the administration, "after attending a few classes and realizing that we'd have to watch the Odessa Steps sequence from *Potemkin* until it came out of our ears."[21] In his art and film work, Waters tends to work within traditional forms and genres, but invests them with less-than-traditional subject matter: selfishness, rudeness, physical flaws, destructive dependencies, the criminal mind, and extremes of personal and cultural delusion. "I've never heard an audience rave, 'Wow, did you see those great reversal shots?' No, filmgoers want a good narrative script and interesting people. Technique even killed the underground film movement of the mid-sixties....Audiences...were bored to tears by abstract experimental films featuring colors jumping around, they gave up and went back to the safety of commercial theaters."[22]

Art-making for Waters is not a break from the movies, but a way to look more deeply into what makes movies powerful.[23] The stills he harvests from art-house failures, potboilers, and cult and popular classics reflect upon—sometimes directly, sometimes obliquely—the impact of movies, and the process of making them. He pays homage to the nerve and showmanship of film directors he admires (*William Castle*, 1995; *Otto*, 1995). He focuses on the details that illuminate how charisma, celebrity, and the fetishism of fans operate (*Liz Taylor's Hair and Feet*, 1996). In *Condemned* (2000), Waters reminds us how sanctimony and censorship serve only to heighten our curiosity and

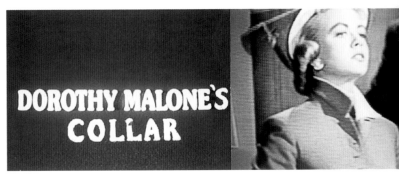

Critical by disposition, yet optimistic by nature, Waters respects our poignant and relentless need to connect with something bigger and better than ourselves. Our constant attempts to remake and repackage ourselves is a theme that turns up frequently in Waters's work, especially when he, himself, is the subject (*Self-Portrait*, 1994; *Face-lift*, 1996). He's honest enough to acknowledge how we're attracted to evil and to fragility equally, finding glamour in both villains (*Manson Copies Divine's Hairdo*, 1993) and victims (*Jayne*, 1998, an homage to the pneumatic voluptuousness of Jayne Mansfield, who died in a 1967 car crash and, as legend has it, was decapitated). Waters shares his fascination with malevolence (*True Crime #2—Scramblehead*, 1992; *True Crime #1*, 1996) as well as an appreciation of the kind of vulnerability that leads to addiction (*Movie Star Junkie*, 1997; *Last Call*, 2003).

Waters is a talker—an entertaining conversationalist, engaging lecturer, and lively late-night talk-show guest. When questioned about his artworks, he is, not surprisingly, extremely articulate and emphatic about what the work is and what it is not. The work is not, according to Waters, about photography. This position

enthusiasm for what's forbidden. In *Hair in the Gate* (2003), Waters devilishly imagines what would happen if defining "money shots" in film history—Julie Andrews on the hill in *The Sound of Music*, the *Titanic* going down, or the Clark Gable/Vivien Leigh kiss in *Gone with the Wind*—were rendered unusable by a sloppy, technical glitch.

might seem odd considering Waters's assertion that his work is all about editing, and considering that photography itself is all about editing—what one chooses to point a camera at, to include in the frame, and to present to others. But Waters is not a photographer in the sense that he's unconcerned with the aesthetic and technical photographic issues that preoccupy

TOP
DOROTHY MALONE'S COLLAR, 1996
Ten chromogenic prints
Checklist #24

most professionals. There's no fussing over cameras, technique, lighting, or framing. The prints he presents are serviceable, but that's all. Waters's purposefully ambivalent relationship to photography gives him an advantage of perspective; what interests him is not photography itself, but photographic culture. He's interested in exploring photography, as Abigail Solomon Godeau described it, as "a mechanically reproducible image making technology wholly assimilated to the apparatuses of consumerism, mass culture, socialization and political control."[24] In other words, what Waters explores and celebrates in his work is how photographic images are used, particularly in the movies, as well as what their usage says about us and means to us.

The power of photographic images and people's need to see themselves represented in and validated by images are themes that run through Waters's feature films and artworks alike. In *Pink Flamingos* and *Female Trouble*, plots are driven by the extreme behaviors of characters who desperately desire public recognition. In a hilarious but dispiriting scene in *Desperate Living*, middle-class, camera-toting tourists flock to Mortville—a hateful town to which criminals ashamed of their crimes are banished—and walk up and down the streets excitedly snapping pictures of abjectness and debasement. In *Hairspray*, a hefty teen longs to become a "regular" on *The Corny Collins Show*, an after-school TV dance party, and once she does finds all that eluded her in everyday life: respect, love, and political empowerment. "Cinema terrorists" kidnap a movie star in *Cecil B. DeMented* (2000) to draw attention to the cultural damage caused by Americans' unquenchable and often unexamined appetite for mainstream movies.

Critical of cultural and political piety, Waters distances himself equally from the pieties in which some photographers cloak their images, work, and egos. As a veteran maker of motion picture fictions, he places no faith in what has been called the "truth" of photography. He doesn't trust single photographic images. What they do best is render details of a split-second moment with unparalleled accuracy; they cannot describe what transpires in the moments before and after a camera's shutter opens and closes.[25] Although Waters occasionally uses

a single photograph to make a point or a pun, he's not obsessed with capturing single "decisive moments;" rather, he is compelled to gather them together in bunches and see what happens.

Waters's relationship to photography, like his relationship to mainstream film, is largely defined by his outsider status and his characteristically oblique but incisive point of view. He's an irreverent but clear-eyed intruder, a filmmaker who has stepped over a border into another disciplinary realm. It is through the process of carving out an interstitial space for himself, a no-man's-land between film and photography, that Waters has found another avenue for expression. With no rules to follow and no allegiances or constituencies to be maintained, he takes whatever he needs from the historic arsenals of film and photographic techniques.

Waters's "little movies" owe a significant debt to montage, the editing technique pioneered by avant-garde Soviet filmmakers early in the twentieth century. In the 1930s, Soviet critic Sergei Tretyakov proposed that photomontage began whenever there was a conscious effort on the part of the artist to alter a viewer's first sense of a photographic image, by joining two or more images together to divert the photographs away from what they "naturally" seemed to communicate. The goal was to manipulate viewers into more active readings of images.[26] Montage, with its purposefully incongruous combination of imagery, is used to jolt viewers out of their complacency. That's what Waters does in *Edith Tells Off Katharine Hepburn* (1995). A surprisingly glamorous still of Edith Massey—a regular in Waters's films whose rumpled, clueless, and irony-free performances caused him to characterize her as the ultimate "outsider actress"—with tongue stuck out and middle finger extended is juxtaposed with an image of Katharine Hepburn, whose mannered and patrician persona Waters found deplorable.[27]

Waters has also drawn upon the works of photographers, from Eadweard Muybridge to Alfred Stieglitz, who have joined multiple photographic images into sequences that create and explore both factual and fictional narratives. In Waters's studio, there's a reproduction pinned up on the wall of F. Holland Day's *The Seven Last Words* (1898). Given Waters's fascination with

DOROTHY MALONE'S COLLAR

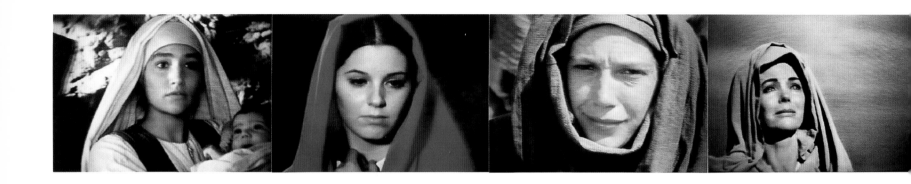

CENTER
SEVEN MARYS, 1996
Seven chromogenic prints
Checklist #30

RIGHT
WILLIAM CASTLE, 1995
One chromogenic print
and one gelatin silver print
Checklist #22

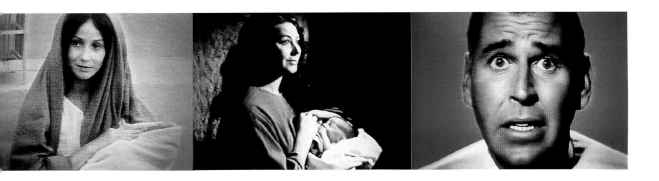

drag and what he calls "Extreme Catholicism," it's clear what drew him to these sequential self-portraits in which Day, posed as Christ on the cross, suffers and, in subtitles, utters the last sentences of his mortal life. Almost a century later, Waters's *Movie Star Jesus* (1996), a collection of film stills extracted from Biblical epics ranging from the pious to the prurient, pays a clear photographic, conceptual, spiritual, and erotic debt to that earlier landmark work of sequential photography.

More contemporary influences can be traced to the works of American photographers and conceptual artists of the 1970s. Duane Michals, most notably among photographers, experimented with sequential images to explore how the "relationships of two or more photographs can be more expressive, qualitatively as well as quantitatively, than a single image."[28] Conceptual artists such as John Baldessari, Eleanor Antin, Bruce Nauman, William Wegman, Dennis Oppenheim, Vito Acconci, and Mac Adams—rejecting modernism's bias against narrative and the humorless self-consciousness of most "so-called serious photography"[29]—experimented with photographic images to create narrative, sequential, and seemingly nonchalant works that were rigorous in intent if not in presentation.

By the late 1970s, the visual interests and career strategies of yet another wave of artists grappled with the difficulties of creating enduring images in a visual culture fueled by the continual elevation, followed by the constant replacement, of images. Encouraged by Warhol's repurposing of pop-culture images to comment on American culture, as well as by Baldessari's sly insertion of narrative film stills into his cryptic photographic collages and sequences, artists such as Richard Prince and Sherrie Levine took the appropriation of images one step further. They rephotographed photographic images made by others and presented them as their own.

In his early photographic work, Prince made no attempts to disguise the fact that he was rephotographing images directly from magazines. These grainy, oddly tinted, and familiar images—cropped and enlarged details from advertisements for cigarettes, watches, and clothing—came preloaded with seductive and focused content. What Prince's work suggested was that seen from a critical distance, these images could be read on other levels too; embedded in them were alternate narratives waiting to be articulated, about desire, class, gender, sexuality, and consumer culture. The work that brought notoriety to Levine

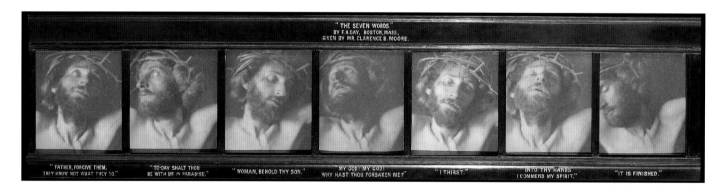

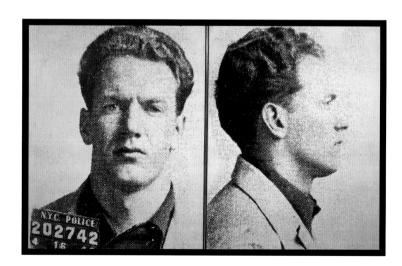

TOP
F. Holland Day
The Seven Words, 1898
Seven platinum prints
Approximately 5¼ x 4¼ in. each; frame size 8½ x 34⅜ in.
Courtesy of Bruce Silverstein Gallery

BOTTOM
Andy Warhol
Most Wanted Men No. 6, Thomas Francis C., 1964
Synthetic polymer on canvas
48 x 38⅞ in. each panel
Courtesy of Gagosian Gallery. © 2003 Andy Warhol
Foundation for the Visual Arts/ARS, New York

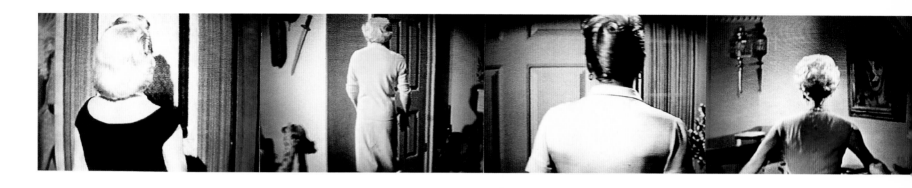

LANA BACKWARDS, 1994
Eight chromogenic prints
Checklist #11

TRUE CRIME #2—SCRAMBLEHEAD, 1992
Six chromogenic prints
Checklist #5

LANA BACKWARDS

concentrated, at first, on her audacious rephotography of iconic images by the insider members of photography's largely male pantheon, raising questions not only about originality but also about the exclusionary biases and narrative blinders of photographic and art history.

Prince's and Levine's unapologetic appropriations of commercial and aesthetic imagery triggered controversy, as did Cindy Sherman's *Film Stills* (1977–82), which appropriated and questioned the stereotypical depictions of women in film. The art world, in which distinctions separating one medium from another were rapidly eroding, was engaged by questions raised in this new work about representation, authorship, and the role of images in consumer culture. The photography community, on the other hand, responded defensively and dismissively. Given photography's recent upgrade to respectability within the gallery, auction,and museum communites,works by artists who turned their backs on the craft of photography, but who drew attention to the ways in which photographic images burrowed into everyday consciousness and prominence, were troubling. To this day, the preciousness and isolation that "serious" photography tends to cloak itself in helps to explain why Waters is so quick to disassociate what he does from conventional photography.

Even as many artists—composing a group as diverse as Jeff Wall, Sandy Skoglund, Sam Taylor-Wood, Gregory Crewdson, and Anna Gaskell—have come to embrace the spectacular production values of movies in their photographic work, Waters has, with characteristic perversity, chosen to work almost exclusively with appropriated imagery. The once-radical technique has now mellowed, and Waters has adapted it to produce work that is demure. He's already seen what the images that erupt from his imagination look like when they're projected large; they have made a substantial impact not only on American movies, but on art and photography as well. It is hard to imagine the works of Paul McCarthy, Jeff Koons, Joel-Peter Witkin, or even Nan Goldin without acknowledging the path that Waters cleared for them in his previous assaults on American propriety.

Drawing upon montage, sequential photography, and appropriation, Waters has found a format that's well suited to his brand of comedy and commentary. Comic delivery demands an exquisite sense of timing; and in his photographic work Waters makes good use of his skills in the selection, presentation, and pacing of imagery. Comic narratives are often built upon improbable juxtapositions of language, circumstances, and values; the success of Waters's "little movies" hinges on his ability to splice together disparate, borrowed images to make a clever pun, or to clear a path to a visual punch line.

Waters is well read, and smart enough to avoid overintellectualizing the work. While the art world may be suspicious of works that elicit a laugh, considering them lightweight, Waters

Richard Prince
Untitled (Mixed couples), 1977–78
Three Ektacolor prints
20 x 24 in. each
Edition of 10 + 2 AP
Courtesy of Barbara Gladstone Gallery, New York

knows that comedy is serious, that "to treat the inhumane world with ridicule is to make it tolerable."[30] He knows that humor can be effective if it demystifies the process of making and looking at art. He knows that "artists who are able to make fun of themselves make themselves vulnerable to us."[31]

Viewers are drawn to the humor and elegance in Waters's work, to the insights and the highly cultivated and oddball perspectives he so generously shares with us. But the underlying strength of Waters's photography comes from something less obvious and, ultimately, more powerful. Waters, no matter how carefully he cultivates and maintains his reputation as a renegade and a taboo-buster, is more than a witty, and now-matured, bad boy. He's a humanist at heart. "The entertainer," curator Marcia Tucker wrote, "tries to remove us, however briefly, from the difficulties and cares of the real world. Artists, on the other hand, never let us escape it for a minute."[32]

Waters wants to amuse and shock us, and is unwavering in his desire to pierce the veneer of politeness that prohibits each of us from admitting who we really are. In his photographic work, Waters is always charming, but also relentless in reminding us that we're all, to varying extents, pimply, self-indulgent, frustrated, angry, ugly, covetous, rageful, and full of prejudice. His brilliance as an artist is built, in part, on his willingness to imagine what gets unleashed and accomplished when repressive personal, social, and cultural strictures are shattered. In these works, Waters pays direct homage to narrative genres that best target and exploit our vulnerability: soap operas, horror movies, crime stories, and credulity-straining lurid tabloid tales. Using still photography, he's made silent movies that deal directly and gleefully with bodily functions, disasters, humiliation, inferiority, voyeurism, spirituality, evil, sin, redemption, manipulation, sexuality, envy, obsession, and errors of taste. And in that process, it's more than a little ironic that Waters, for all his disavowals of photographic tradition, has become a consummate "concerned photographer" who never lets us avert our eyes from the humor and the pathos of the human condition.

[1] Manuel Vidal Estévez, "Photography and Cinema: A Journey There and Back," *Exit: Image and Culture*, no. 3 (August–October 2001): 122.

[2] John Waters, *Director's Cut* (Zürich and New York: Scalo, 1997), 283.

[3] Ibid.

[4] John Waters, interviewed by Robert Thill, "The Only Thing in a Movie Scene That You Are Not Supposed to See," *Transcript* 3, no. 3 (June 1998): 121.

[5] John Waters, *Shock Value: A Tasteful Book About Bad Taste* (New York: Thunder's Mouth Press, 1981, rev. ed. 1995), 24.

[6] Ibid., 26.

[7] John Waters, quoted in Juan Guardiola, "My Little Movies (The Director's Cut)," *Exit: Image and Culture* no. 3: 97.

[8] John Waters, *Shock Value*, viii–ix.

[9] John Waters, quoted in Colin de Land, "A Conversation with John Waters," *Parkett*, no. 49 (1997): 8.

[10] Ibid., 12.

[11] John Waters, quoted in Carlo McCormick, "Confessions of a Movie Star Junkie," *Juxtapoz*, no. 19 (March–April 1999): 36.

[12] John Waters, quoted in Guardiola, 96.

[13] John Waters, quoted in Vidal Estévez, 120.

[14] John Waters, interviewed by Robert Thill, 121.

[15] John Waters, quoted in de Land, 6.

[16] John Waters, press release for the exhibition *Low Definition*, American Fine Arts, Co., New York, Novermber–December 1998.

[17] Ibid.

[18] Roland Barthes, "The Third Meaning," in *Image-Music-Text*, trans. Stephen Heath (New York: Hill and Wang, 1977), 67, 122.

[19] See Roland Barthes, "Structural Analysis of Narratives," in *Image-Music-Text*, 79–80.

[20] John Waters, press release for the exhibition *Straight to Video*, American Fine Arts, Co., New York, November–December 2000.

[21] John Waters, *Shock Value*, 44.

[22] Ibid., 138.

[23] Vidal Estévez, 120.

[24] Abigail Solomon Godeau, "Playing in the Fields of the Image," *Afterimage* 10, nos. 1–2 (Summer 1982): 10–12.

[25] See Max Kozloff, "Through the Narrative Portal," *Artforum* 24, no. 8 (April 1986): 88.

[26] See Christopher Phillips, *Introduction to Montage and Modern Life 1919–1942* (Cambridge: MIT Press; Boston: Institute of Contemporary Art, 1992), 28.

[27] John Waters, audio commentary included on the DVD version of *Desperate Living*, directed by John Waters (1977; New Line Home Video, 2001).

[28] David Bourdon, *(Photo) (photo)²…(photo)ⁿ: Sequenced Photographs*, exh. cat. (College Park: University of Maryland Art Gallery, 1975), 6.

[29] Nancy Foote, "The Anti-Photographers," *Artforum* 15, no. 1 (September 1976): 46.

[30] Donald Kuspit, "Tart Wit, Wise Humor," *Artforum* 29, no. 5 (January 1991): 94.

[31] Marcia Tucker, "Not Just for Laughs: The Art of Subversion," in *Not Just for Laughs*, exh. cat. (New York: The New Museum of Contemporary Art, 1981), 19.

[32] Ibid., 26.

PUKE IN THE CINEMA, 1998
Ten chromogenic prints
Checklist #46

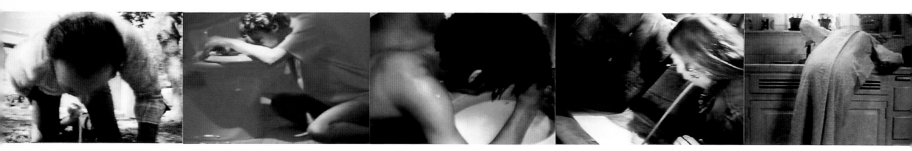

PUKE IN THE CINEMA

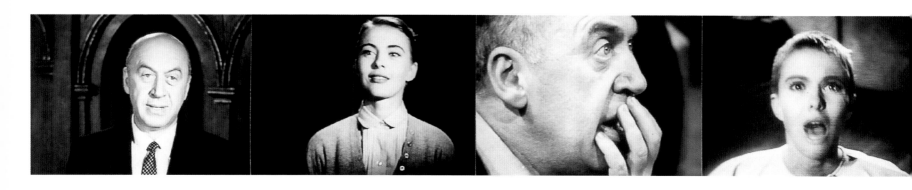

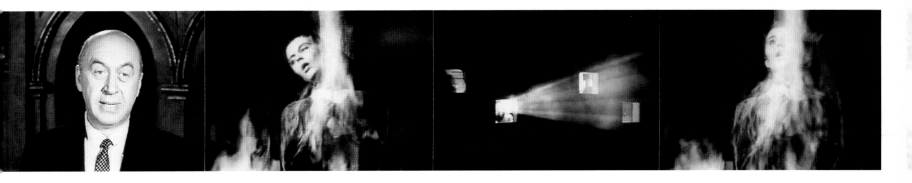

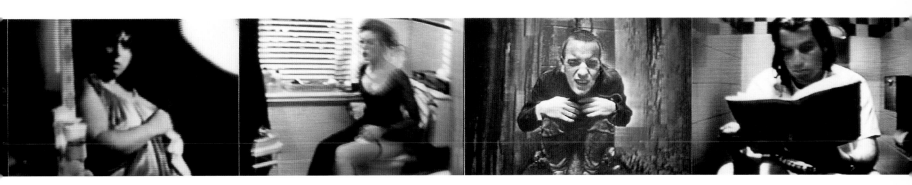

CENTER
OTTO, 1995
Eight chromogenic prints
Checklist #20

BOTTOM
TOILET TRAINING, 2000
Nine chromogenic prints
Checklist #63

44

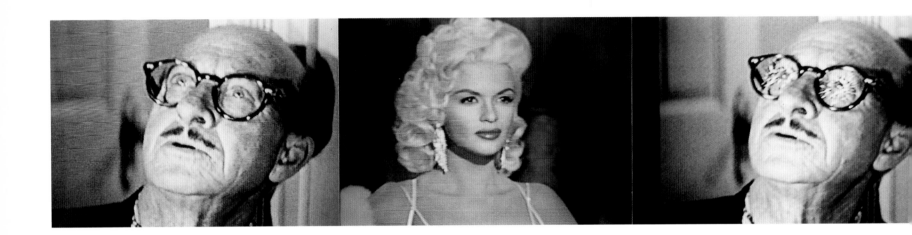

TOILET TRAINING

TOP
JAYNE, 1998
Three chromogenic prints
Checklist #40

RIGHT
EDITH TELLS OFF KATHARINE HEPBURN, 1995
Two chromogenic prints
Checklist #18

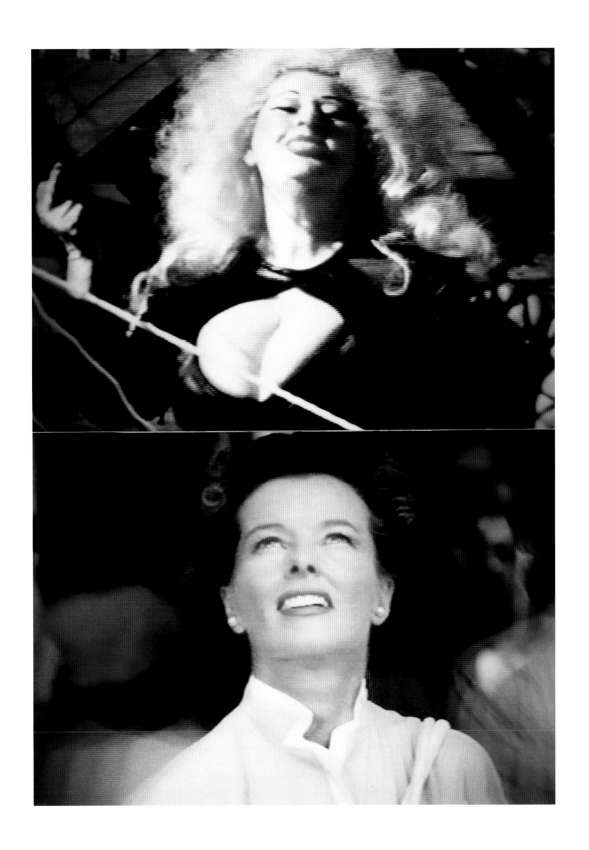

46

TOP
MOVIE STAR JUNKIE, 1997
Eight chromogenic prints
Checklist #34

BOTTOM
LAST CALL, 2003
Eight chromogenic prints
Checklist #69

CENTER RIGHT
TRUE CRIME #1, 1996
Four chromogenic prints
Checklist #31

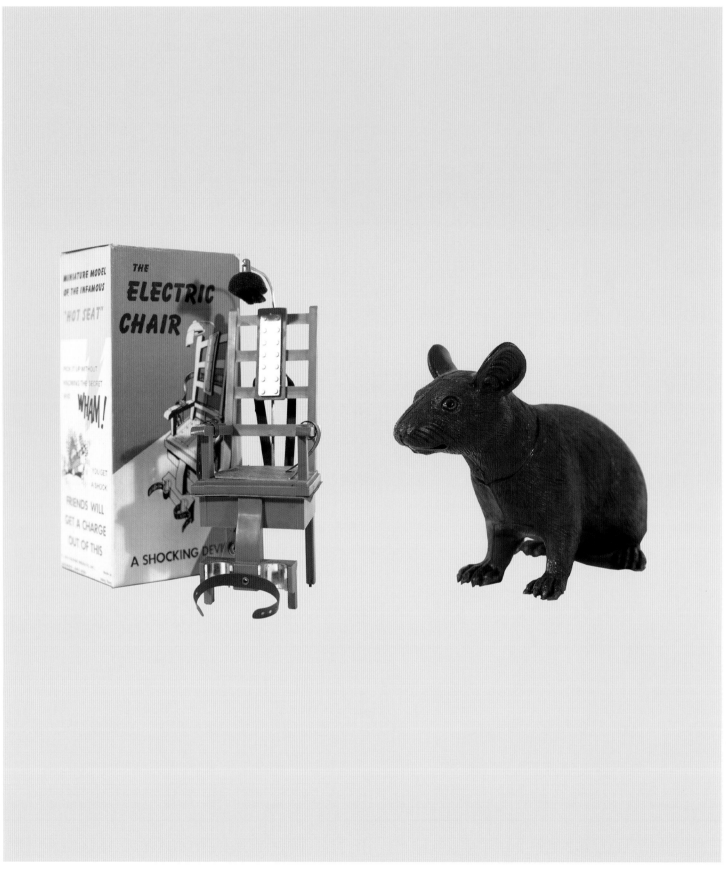

LEFT
Electric chair toy from the
personal collection of John Waters
RIGHT
Toy rat from the personal
collection of John Waters

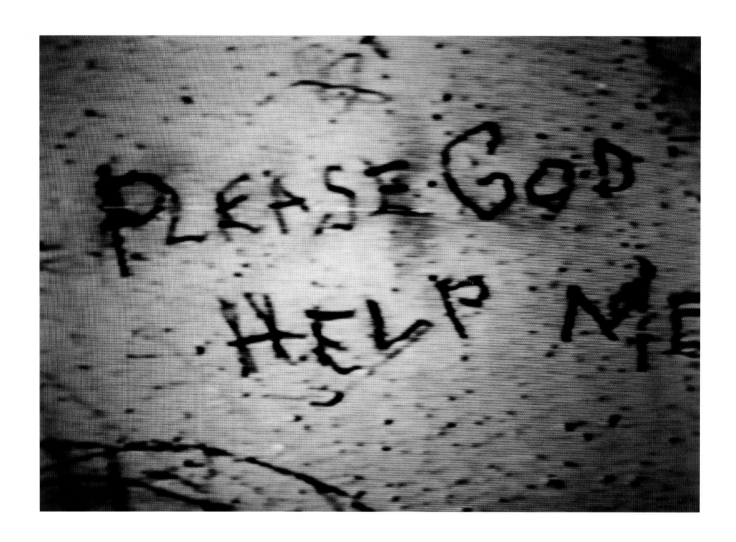

PLEASE GOD, 1998
Chromogenic print
Checklist #45

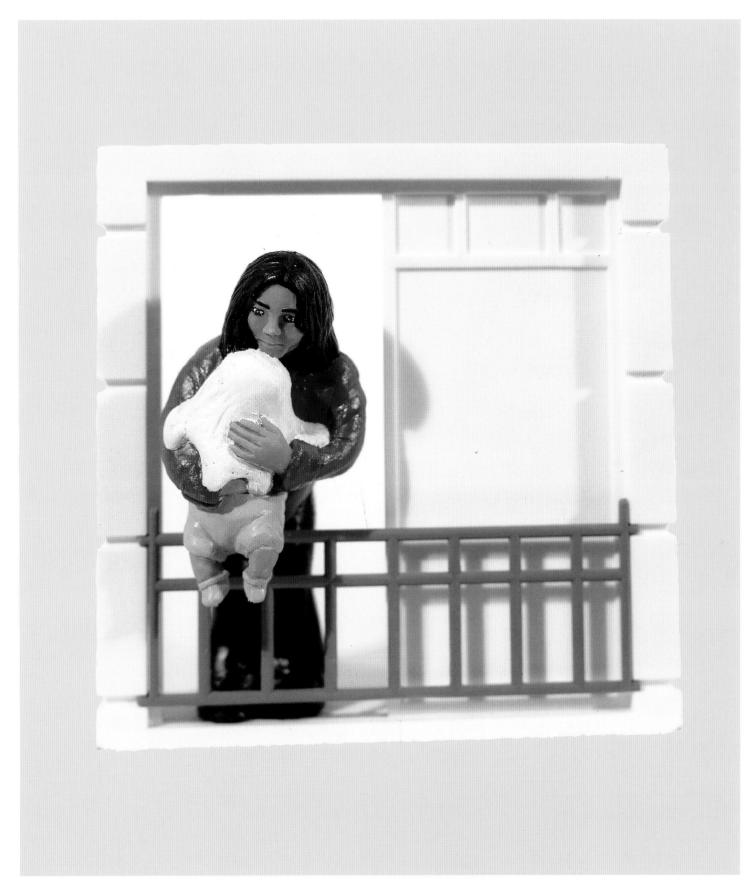

Baby Drop, mass-produced
6 x 6 x 2 in. cast resin sculpture
produced by Emil Vicale from
the personal collection of
John Waters

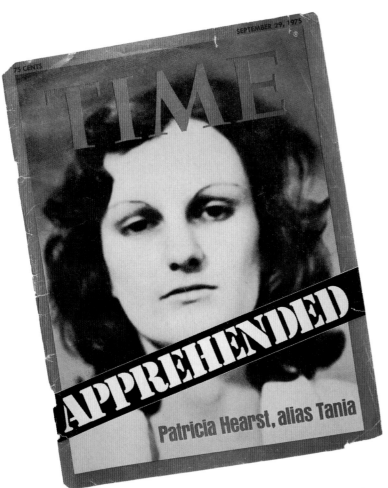

TIME

SEPTEMBER 29, 1975

75 CENTS

APPREHENDED

Patricia Hearst, alias Tania

WATERWORKS

Gary Indiana

One persistent, important theme running through John Waters's work is the idea that fame, while shaped to a certain extent by a dominant culture, operates quite differently among the consumers of fame than it does in the minds of the people who manufacture it. Fame, in the American context, equals existence itself—this is a country where the idea of "being somebody" means that other people know about you. Even the Unabomber needed his fifteen minutes of fame to feel that he really existed.

Waters's early films are somewhat like Andy Warhol's in their mimicry of the Hollywood studio industry, including the notion of homemade celebrity and a star system manufactured out of available and vivid people in one's own environment. Warhol proposed his coterie of beautiful people as an alternative to the mainstream A-list. Waters went further by making his beautiful people grotesque. Films such as *Pink Flamingos* (1972) and *Desperate Living* (1977) feature personalities who are, or are made up to look like, negatives of movie stars. Limited by miniscule budgets, the representation of celebrity in these films has a definite local flavor: it seems to be only in Baltimore that the title "the filthiest people alive" commands headlines; and Dawn Davenport's apotheosis in the elec-

tric chair, in *Female Trouble* (1974), is enshrined by only a few skimpy flashbulbs. Still, the metaphor of America as a place where the criminal impulse and the craving to be well known are more or less the same thing has become even more resonant in the years since these films were made.

Warhol was transgressively in love with glamour. At the same time that his films were reaching a restive subpopulation of intellectuals and artists, Warhol laid claim to the unreachable objects of his fascination in his portraits of Marilyn Monroe and Liz Taylor. And eventually his silkscreens achieved a parity of glamour with their subjects, traded on the same gold standard. The marginal becomes the defining artifact of its era, inscribed in history. Warhol's films, with their overt sexuality, were like emanations from the unconscious of Hollywood.

Something similar happens when Waters begins using "real" movie stars in his movies. Like a retroactive endorsement of the anal probe approach to cinema embodied in a film like *Polyester* (1981), the appearance of stars such as Kathleen Turner and Melanie Griffith in *Serial Mom* (1994) and *Cecil B. DeMented* (2000) respectively signals a shift in the culture—not only an absorption of a kind of extreme content, but an evolution of sensibility. Waters has become an auteur in a small constellation of American directors with whom it is desirable to work in order to partake of a certain vision. It is inspiring to consider that working for the vision in question would have been considered, thirty years ago, comparable to making a porn movie.

Both Warhol and Waters unleashed a queasy, complex element of overt homosexuality into the avant-garde. Warhol as film director is a model of expanding the permissible, evidenced in the amphetamine monologues of his actors, his epically extended fixed shots, the unexcited display of genitalia, and the depiction of banal activities. Warhol is droll, passive, an icon of silence. His serene passage from outcast to saint now seems an inevitable fait accompli.

Waters is in many ways a more difficult figure than Warhol, a more obviously contentious influence on contemporary sensibility. The trailer in *Pink Flamingos* (1972) may very well be the quintessence of everything the people in Warhol movies were scrambling to get away from. Although there is an obvious celebration of Americana, kitsch, and "democratic leveling" in Warhol's work as a whole, the phenomenon of the Factory epitomized a kind of elitist enclave common in Manhattan cultural circles throughout the 1940s and 1950s: it simply took the drugs, the sex, and the craziness out of the closet.

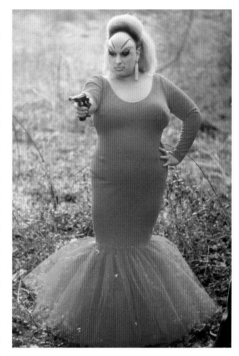

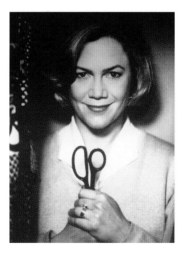

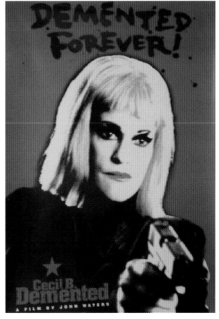

TOP
Still from *Pink Flamingos*, 1972, featuring Divine as Babs Johnson

CENTER
Still from *Serial Mom*, 1994, featuring Kathleen Turner as Beverly Sutphin

BOTTOM
Poster for *Cecil B. DeMented*, 2000, featuring Melanie Griffith as Honey Whitlock

In Waters's Dreamland Studios, the glacial cool of the Factory is replaced by superheated abjection and chutzpah. Waters's work begins at the nether end of things, where the torments of high school and the stigma of difference produce a gleeful embrace of "lowlife" that is never bored, or boring. While the Warhol universe included sleaziness in its

menu of pleasures, Waters fashioned from it a strangely unified and contrary vision. Warhol created superstars from beautiful people with blemishes. Waters focused on the blemishes, insisting that we see them as beautiful.

One can't set these two artists in opposition, as they moved along parallel tracks, and both brought more and more of what had been alien to art into glorifying highlight.

It's probably easier for a wide audience today to see something beautiful in Waters's fixation on American ugliness. The culture has become infinitely uglier, but in a plastic rather than organic way, and the rites of celebrity conferred on the pathetic and the fifth-rate, exemplified by "reality TV," have taken on a wildly improbable, lottery feeling that casts Waters's stars—Divine, Edith Massey, Mink Stole, Mary Vivian Pearce, et al.—in the richly glamorous, selective light they deserve.

At the same time, much of "the forbidden" touched on in these films has become the accepted, even the banal. With regard to homosexuality, the ideas about it reflected in Divine's enormous presence throughout Waters's early movies, in the lesbian dystopia of Mortville in *Desperate Living*, and in Edith Massey's dialogues in *Female Trouble* are intriguingly premonitory of a time when the whole issue of "gayness" would become less provocative than the basic clash between individuality and conformity at the heart of Waters's work.

On one hand, there is a vigorous, hilarious promotion of sexual nonconformity as superior to the dullness of heterosexual norms; on the other, a critique of normality in general that encompasses the normalization of homosexuality, which Waters undoubtedly foresaw in the early 1970s.

Already in *Desperate Living*, visual evocations of gay culture—in Queen Carlotta's leather-boy militia—point to something running askew. Though the physicality of the actors is far from the sculpted images of perfection typifying contemporary gay stereotypes, Waters intuited the postlib-

CENTER
Still from *Desperate Living*,
1977, featuring Steven
Butow and Jean Hill

BOTTOM
Still from *Desperate Living*, 1977,
featuring Liz Renay
as Muffy St. Jacques with
Queen Carlotta's leather-boy militia

TOP
THE HOT SEAT, 2001
Eleven chromogenic prints
Checklist #64

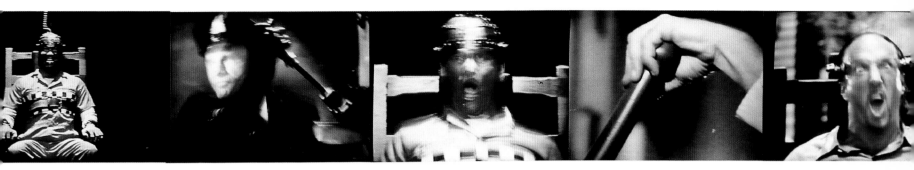

eration tendency toward fascist uniformity that manifested itself with uneasy frivolity in the disco phenomenon and then became uglily concretized in the figure of the West Village clone. There is, Waters implies, nothing special about being gay if you're a wretched person; in fact, you might become more brutal and insensible than the people who oppress you, if your "identity" is used to wield power.

While Waters himself traffics in exaggerated stereotypes—the male hairdressers in *Female Trouble*, for example—the social matrix underlying the early films suggests implicitly that difference affords the possibility of empathy with the supposedly abnormal. Little moments of friendship and kindness among various freaks recommend the idea that nothing human is alien if you're an alien yourself. The external social order, thriving on exclusion, is shown to be peopled by other kinds of freaks, blessed with money and the will to power. They are ourselves gone bad, in the depressing tradition of American communities defining themselves by stigmatizing a demonic Other.

The embrace of Otherness in Waters's films is never uncomplicated: his speciality is going overboard. The birthday party in *Pink Flamingos* begins as a libertarian love-in, complete with a performing asshole, but degenerates from saturnalia to cannibal feast. This hallucinatory excess is a powerful element that adds layers of ambiguity to the good-natured themes of Waters's films, which engage the powers of disgust and horror as deliberate aesthetic ruptures, a procedure articulated in sets, costumes, makeup, and characters.

In keeping with the period of their making, these films entertain the possibility of liberation through an overturn of the social order. But this idea is portrayed in such hyperbolic terms that the political becomes the daft hyperenlargement of the personal—in the embrace, say, of such symptoms of alienated psychopathology as the Manson family.

Films like *Desperate Living* force us into identification with braying, screaming, scarred, pockmarked, monstrously obese and, finally, rabid people whose dreams and desires are gross and pathetic; yet the force of metaphor is such that they seem to exist already in our unconscious before they come tumbling onto the screen—we want them to win, because in some horrific, buried way, they are us.

Waters's faux-naive constructions usually involve a stark linear simplification of dramatic "conflict." His stories stress generative and expansive possibilities of difference, linking the view of the

THE HOT SEAT

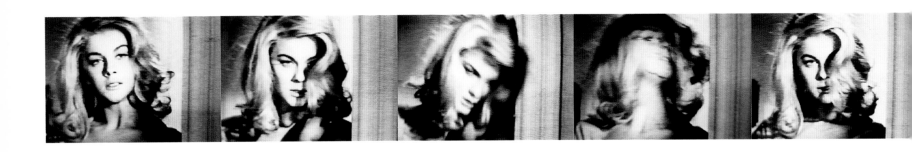

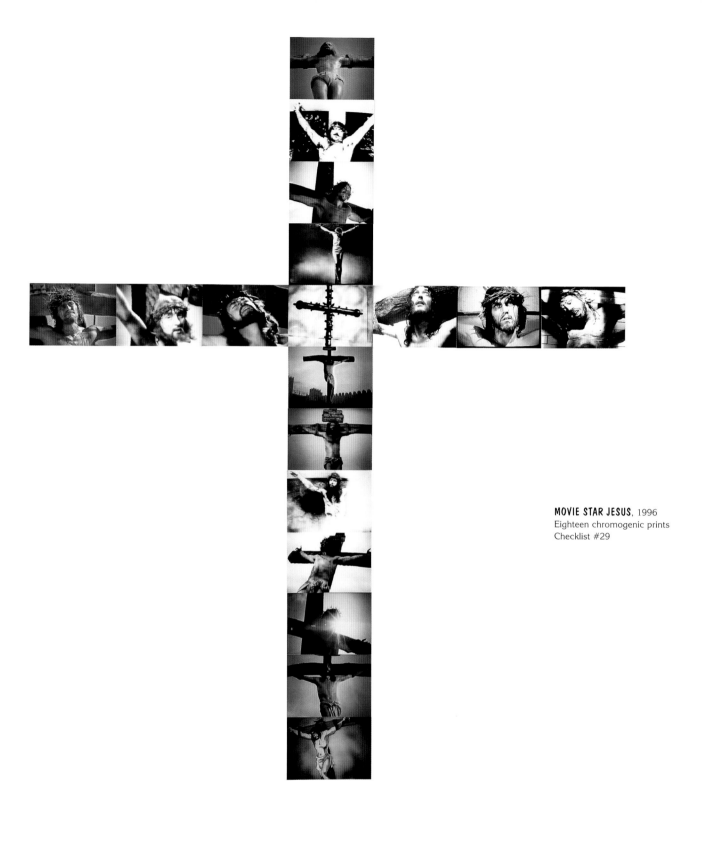

MOVIE STAR JESUS, 1996
Eighteen chromogenic prints
Checklist #29

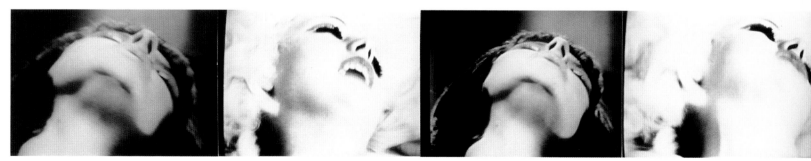

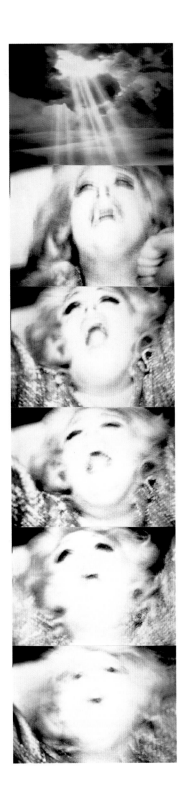

LEFT
DIVINE IN PRAYER, 1995
Six gelatin silver prints
Checklist #16

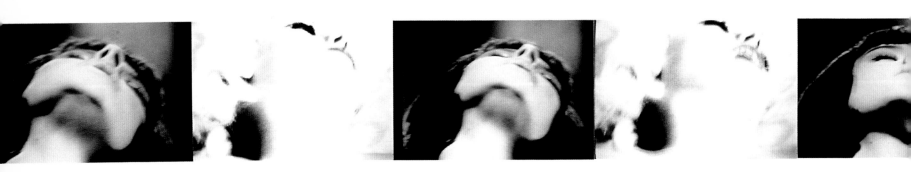

I, MARY VIVIAN PEARCE

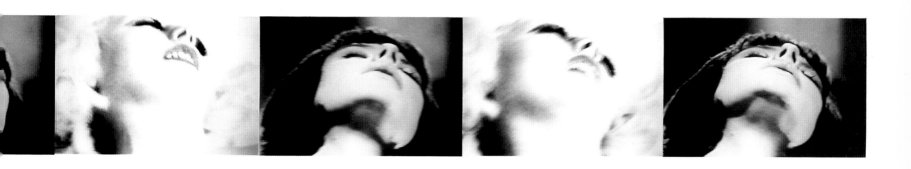

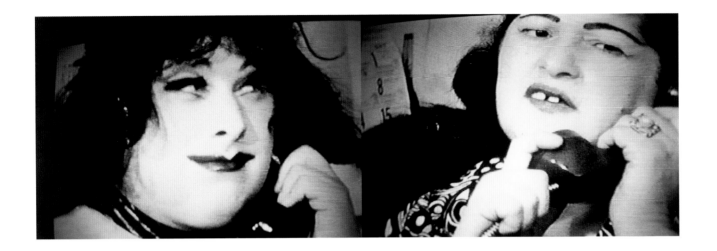

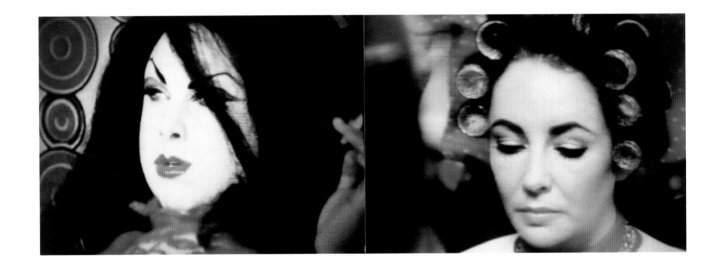

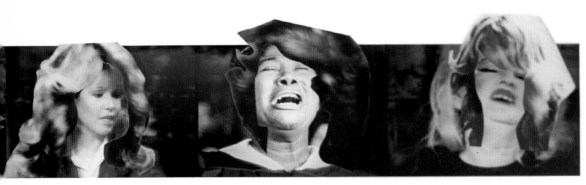

FARRAH

sexual outsider to other disfavored persons in society, especially those pushed to the furthest margins. The criminal is seen as the more interesting reverse side of an asphyxiating status quo. Waters loves to represent courtrooms and jails as the key institutions of American life conferring "stardom." It is simply the case, as crime novelist Patricia Highsmith once noted, that criminals are more interesting than other people. The desire to "make it" by breaking the law is merely a louder whisper of the truism about artists "making it" by breaking all the rules. Waters's work places the very nature of aspiration before us as something inexorable in human nature, akin to leaf mold or viral contagion; all his characters are infected with it.

We can also find the roots of his sensibility in the celebration of black culture in *Hairspray* (1988). The film locates the vitality of American culture in the black experience and depicts the natural affinity between alienated white youth and the country's historical Other. It also urges us to see beauty in people traditionally viewed as flawed, or "unbeautiful." There is no doubt that the bizarre Southern eccentricity of Baltimore's working class and unemployed, along with its jittery racial mix, feeds Waters's work in ways that a visit to Baltimore makes instantly legible. The city's hyperbolic aspect, its vast assortment of human wreckage, its libidinal ease (manifested in the country's highest venereal disease rate), the port-town dangerousness of its streets all greatly account for the tweaked, often bleary and depressed atmosphere of Waters's films, which despite their manic content tend to locate their characters in dismally limiting, Dickensian settings.

Waters's sets are often stuffed with plangent kitsch specific to a working-class, honorary Catholic piety; religion, in Waters's work, is always a marker of unpleasant fanaticism or erotic displacement. Its primary association is with the hopeless classes; the higher rungs of the social ladder tend to be secular, yet even more airless and stultifying. The upper middle class depicted in *Serial Mom* is a notch higher than usual in terms of affluence, but somehow, in its seemingly shadowless normality, more horrifying than the others.

LEFT
Still from *Hairspray*, 1988,
featuring Ricki Lake as Tracy Turnblad

RIGHT
Still from *Pecker*, 1998, featuring
Jean Schertler as Memama
and Cindy Sherman as herself

Waters's rendering of Baltimore as a wank American microcosm captures the desuetude, quirkiness, and sad limitations of many of America's "secondary cities." Waters, a fan of Polish writer Witold Gombrowicz, transposes the Gombrowiczian discourse on "secondary cultures" (Poland vs. France, for example) to the weirdly inflected, homogenized realm of small- and middle-town America, the places so many people marked by difference ran away from and which became repositories of a mannerist version of popular culture, sprouting wild variants on styles long out of date in "major" cities.

Peculiarly, this mannerist form may now be more authentic than the "big" cultures of New York or Los Angeles, where fewer and fewer genuine local identities survive the many cycles of gentrification. Like Gombrowicz, who frankly acknowledged that Poland was an unimportant culture and embraced its provincialisms to the horror of its literary elite, Waters assimilates his Baltimore to the seediest remnants of pop culture generally, not least in such casting coups as using Tab Hunter in *Polyester*, Liz Renay in *Desperate Living*, and Traci Lords in *Cry-Baby* (1990). Waters's casts are themselves statements about cultural hierarchy, pastness and with-itness, marginality and centrality, the fluid movements between different categories of celebrity and notoriety, and the American genius for reinvention. A forgotten starlet can, in a Waters film, appear simultaneously as a parody of herself and as a star of greater-than-original wattage, while a "real" star enlarges our idea of him or her as someone who shares our appreciation of the grotesque and the messily sexual, among other things. Most blatantly in *Pecker* (1998), Waters takes "the big culture" down to Baltimore, where the cardboard bohemia of New York clashes with the real thing.

Although there can be something homiletic about Waters's "message," one of his great strengths is that his work is never mean-spirited. If the occasional element of corn or sentimentality makes some of his original audience wince, it goes down easily with segments of middle America who can only benefit from what Waters is really putting across. His films are a tonic for alienated Americans who

LEFT
Still from *Polyester*, 1981, featuring
Tab Hunter as Todd Tomorrow
and Divine as Francine Fishpaw

RIGHT
Still from *Cry-Baby*, 1990, featuring
Traci Lords as Wanda Woodward

INGA #1, 1994
Six chromogenic prints
Checklist #10

64

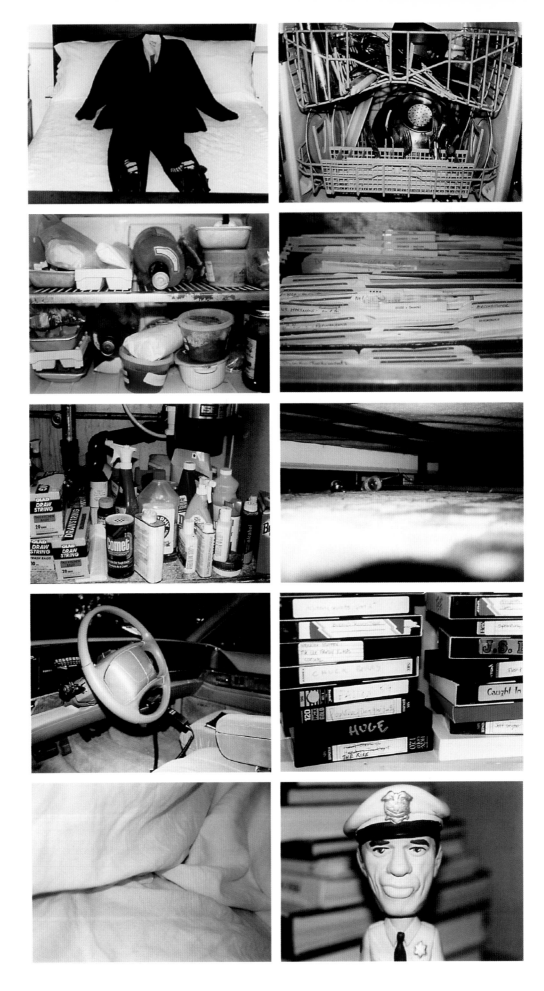

AT HOME, IN MY DISHWASHER,
IN MY FREEZER, IN MY PRIVATE FILES,
UNDER MY SINK, UNDER MY BED, IN MY CAR,
IN MY VIDEO CLOSET, UNDER MY COVERS WITH ME,
and IN MY MIND from the "In My House" series, 1998
Ten chromogenic prints
Checklist #39

feel that they lack existence, that their flaws and secrets are disgusting, that they don't measure up to the images constantly thrown at them by the mass media: the films are, in effect, an antidote to abjection, urging people to foreground their difference as an asset. To be known, you have to be something, but in Waters's scheme of things, the weirder that something is, the better.

The drastic version of being known that Waters portrays so often, in figures such as Pecker, or Honey Whitlock in *Cecil B. DeMented*, reflects a dilemma intrinsic to the embrace of an identity, particularly gay identity. Waters has deftly avoided the boxing-in effect of being typed a "gay artist," concerning himself instead with how difference plays out in many American arenas, eschewing the narrow focus that limits so much "gay art" of recent years. Waters has inscribed himself as an American icon in much more extravagant terms than that.

He is typically identified as a purveyor of trash, the king of sleaze, an avatar of bad taste; by now these designations sound a little shopworn, since he is obviously a highly articulate and intelligent artist, who may not have known exactly where his work was going at the start of his career, but certainly knew what he wanted to draw attention to. His embrace of subjects beyond the pale of "serious" artistic representation has also led him to discard certain aesthetic procedures, the absence of which gives his work a sometimes ragged quality, though the Sirkian patina of *Polyester* and a film like *Serial Mom* amply prove that Waters knows how to do a lot of things he doesn't bother doing in a lot of his films.

It would be natural to ask what the photographs and sculptures he has been showing in galleries for several years have in common with his films, since the "fine art" context would seem distinctly at odds with the special category of cinema Waters has carved out for himself. But it may be that the realm of popular culture Waters has parodied, exploited, and celebrated with such a giddy eye over the years has achieved precisely the lava-lamp incandescence of a rarefied cultural moment.

Still from *Pecker*, 1998, featuring Lauren Hulsey as Pecker's sister Little Chrissy

Art has a lot in common with taxidermy. Waters has always been busy embalming moments of American life into waxworks of contradiction and lunacy, often with an attention to fetishistic detail that works especially well in a photograph. Just as his films tend to interrogate everything considered necessary in the construction of cinematic illusion, the montages and close-ups and partial frames captured in his photography isolate fragments of that illusion that emit special meanings to the viewer regardless of the intention of the detail's larger context.

In what he selects from the traveling circus of popular culture, Waters identifies what is "his"— what leaps out to mirror his preoccupations. He subsumes the inflated figures of mainstream discourse into the fetish territory mapped in his movies. The effect is both leveling and liberating. If movie stars are our gods and the movie theater is church, then Waters is an anti-Pope artist, demoting one layer of celebrity by canonizing less exalted ones. In these "static" works, Waters has found an entirely fresh way to frame his obsessions. Recycling his own iconography, along with Hollywood's, he reinvests the paling glamour of the incidental and the obscure with the grandeur of recovered memory.

Still from *Pecker*, 1998, featuring Edward Furlong as Pecker and Christina Ricci as his muse, Shelley

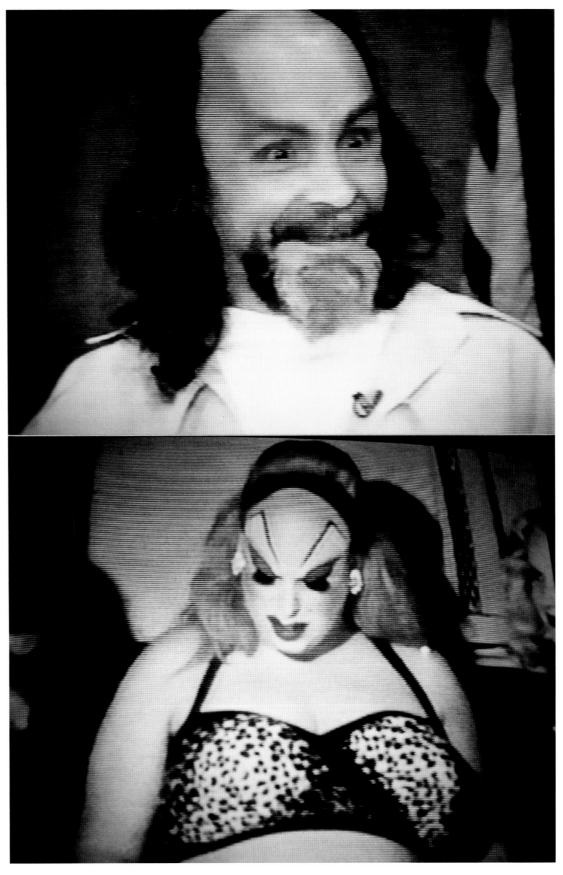

MANSON COPIES DIVINE'S HAIRDO, 1993
Two chromogenic prints
Checklist #6

67

TOP
MANSON COPIES BRAD PITT, 2003
Two chromogenic prints
Checklist #70

CENTER
**MANSON COPIES
DOROTHY MALONE'S COLLAR**, 1998
Two chromogenic prints
Checklist #41

BOTTOM
MANSON COPIES RICHARD GERE, 2000
Two chromogenic prints
Checklist #57

TWELVE ASSHOLES AND A DIRTY FOOT, 1996
Thirteen chromogenic prints with velvet curtains
Checklist #32

TOP RIGHT
Detail with curtains closed

Tear sheet from the *National Enquirer* from the personal collection of John Waters

Christmas gift from Ray Heuttner, which became the mascot for John Waters's studio. From the personal collection of John Waters

SHUT UP, 2001
Chromogenic print
Checklist #65

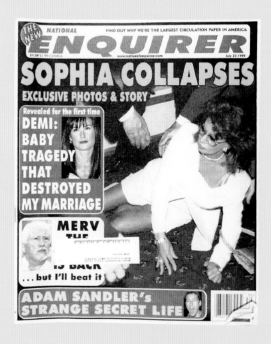

Coloring book and magazines
from the personal collection of
John Waters

Books from the personal collection
of John Waters

Books from the personal collection
of John Waters

LOOKING FOR ART
IN ALL THE WRONG PLACES
JOHN WATERS'S SURROGATE DRAWINGS

Brenda Richardson

In 1997, while shooting his movie *Pecker* (1998), John Waters noticed that crew members were unintentionally "making drawings for me" as they laid down the floor marks designating the positions of the actors for each shot.[1] These positioning or memory marks are essential to successful filming. The movie director and the D.P. (director of photography) together make the decisions about how each scene will be shot. Cameras, lighting, sound, furnishings, and actors' movements are all keyed to those decisions; calculations are precise and interdependent. Then the crew sets down the marks that choreograph the vision outlined by the director and the D.P., and the director calls for action. Now all the balls are in the air and every time an actor misses his or her mark, film footage will be out of focus and the scene will have to be reshot.

Most marks are laid down in colored tapes. Actors are each assigned a color for their marks (see, for instance, *Mark #12* in Waters's photo-piece *Mark #1–Mark #15* [1998]). Positioning marks for actors are T-shaped to indicate placement of one foot on either side of the T's stem, with the toes touching the crossbar. There are also tracking marks to indicate the directional movement of the camera; the straight lines of black tape in *Mark #5* and *Mark #7* are most likely fragments from the set-up for one of these dolly shots. Positioning marks for furniture are sometimes in chalk (see the marks for chair legs in *Mark #9*). And a penciled X in *Mark #6* is a memory mark scratched on a bridge at an exterior location to indicate where the camera should be positioned when shooting continued the next day.

The *Marks* photographs are stealth shots. In filmmaking, time is money, and to squander minutes is a venal sin. When a new camera set-up is called for by the director, the set is cleared and the crew tears up the tape and obliterates the marks in preparation for setting up and marking out the next scene. Once it occurred to Waters that he wanted to photograph *Pecker*'s positioning marks, he knew he would need to work fast. At first, Waters reports, the cast and crew didn't notice what he was doing. He took the photos quickly and without fuss; he didn't need assistance, he didn't ask for

TOP
"Old Art Ideas" file from
the personal collection
of John Waters

RIGHT
MARK #1–MARK #15, 1998
Series of fifteen chromogenic prints
Checklist #42

TOP
SOPHIA LOREN DECAPITATED, 1998
Six torn chromogenic prints
Checklist #48

RIGHT BOTTOM
THREE SIRK MIRRORS, 1998
Three chromogenic print cut-outs
Checklist #50

furniture or equipment to be moved out of the way, he wasn't dressing up the image. He framed the shot he wanted and clicked the shutter. His art-making was entirely covert. After a few days, however, the crew began to catch on. Waters was afraid the technicians would become self-conscious and try to make their marks more artistic somehow. But there's no enhancing a movie's positioning marks. They are what they are and where they need to be; the colors and configurations are preordained. "Marks are never wrong," Waters laughs.

Marks may never be wrong, but everything *but* the marks can go wrong in filmmaking. In the *Marks* photographs, Waters shares with us the director's dream set: everything he sees in his mind's eye is articulated in those tapes, every detail is under his control. The actors who miss their mark or flub their lines are nowhere in sight; the lighting that casts a defacing shadow across the star's cheek is dimmed; the extra who mistakenly moves into frame is vaporized. Marks take direction flawlessly. The irony of *Mark #1–Mark #15* is that everything the moviegoer is supposed to see is invisible and everything the moviegoer is *not* supposed to see is revealed. "Art" is turned inside out. The artless and the "pitiful" (a favored adjective that Waters uses as a compliment) become the photographer's elegiac subjects.

Waters says he photographed virtually every mark of every scene in *Pecker*, generating "at least a thousand photographs, maybe more." For the final selection, Waters sequenced fifteen images, exhibited together in a specified numerical sequence, one through fifteen.[2] Most, maybe all, of the *Marks* images relate to scenes in the film (as opposed to those that ended up on the cutting-room floor). Not that it matters. Waters was composing abstract images, and he wants us to see abstract art, "drawings," mark-making. He can look at each of the *Marks* and see every character, recite the dialogue, recall the camera track, know which scene comes next. But that's not what he wants *us* to see, and that's not the context in which he conceived *Mark #1–Mark #15* and framed each shot.

Perhaps in fond tribute to the actors he so merrily banished from the *Marks* photos, or maybe just to show the rest of us how the pros do it (just look at all those toes hitting their marks!), Waters also created a series of posed compositions during the *Pecker* shoot. From a selection of those images he created the photo-piece titled *Hit Your Mark* (1998). Several of the *Pecker* actors, all in character, "hit their marks" for Waters's Nikon. (The movie's photographer-hero, Pecker, and his sugar-addicted sister Little Chrissy, in retro flower-power boots, appear third and fourth from left.) A movie-obsessive's shoe fetishism, Waters jokes, may have had a part in his decision to create *Hit Your Mark* to complement *Mark #1–Mark #15*. He points out that we almost never see feet and shoes in movies. (Since we can't see the positioning marks without violating the cinematic fiction, it stands to reason that we're not very often going to get a glimpse of the feet that hit those marks. But how many of us think about the absent shoes and feet when we're watching a movie?) Waters's transgression isn't clandestine fetishism, however; it's his sharing of professional secrets, like the magician explaining his own illusion. He craftily shows us what in moviemaking is forbidden to audience eyes and, in doing

so, reminds us not to be too smug about what we define as art. As Waters has Shelley say to her boyfriend, Pecker, "You're crazy, you see art when there's nuthin' there."

Waters has been absorbed in the world of art seemingly forever. He was taken to Baltimore's art museums as a child, developing a love for modern abstract art from a very young age. Only a decade or so later he was making rules-flouting movies in Baltimore and moving comfortably within his own circle of like-minded rules-flouting artists and performers in both Baltimore and San Francisco. Following on the notoriety of *Pink Flamingos* (1972), Waters was also embraced by the New York film and performance community, including the still-outré Warhol circle. By the late 1980s Waters had a high profile—as a radical creative force in the movie world—among the artists, dealers, curators, and critics of New York's influential contemporary art community. He became a compulsive gallerygoer, making the art rounds in New York and other cities in the course of his frequent travels. Always an avid reader and book collector (focused primarily on film subjects, biographies, and contemporary literature), Waters began to build his holdings of art books, systematically acquiring a comprehensive library of works on contemporary art and the artists he most admired. At the same time, he also began to expand the scope of his personal art collecting, becoming a serious collector of contemporary art (primarily drawings and photographs) and demonstrating a rigorous intelligence, sharp wit, and astute eye as he defined his taste.[3]

Waters's taste in contemporary art is idiosyncratic, wide-ranging, and obdurate (hence, unpredictable). He can be thrilled by the audacity of Cy Twombly, the nuance of Brice Marden, or the lucidity of Ellsworth Kelly, for example. At the same time, he responds with humor and kinship to the appropriation and narrative art of the 1980s (Richard Prince, Cindy Sherman, and others) as well as to the unconventional personal expressions of artists as diverse as Carroll Dunham, Peter Fischli and David Weiss, Tom Friedman, Mike Kelley, and George Stoll. He delights in the Minimalist vocabulary of the late 1960s and early 1970s (Mel Bochner, Robert Ryman, Richard Serra, Richard Tuttle), even though he got to much of it belatedly, when it was already "historical." Warhol and Lichtenstein, as far as Waters is concerned, are in a class of their own. Similarly, photographers who epitomize the transgressive—Diane Arbus or Larry Clark, for example—figure prominently in his pantheon.

All the artists whose work Waters admires exercise "nerve and wit," he says, by which he means "elitest, arrogant *edge*." He believes that artists with that kind of edge are "asking people to accept as art something they never would have before they saw this work." These artists are "witty," he goes on, which he further defines as meaning "they are intelligent and they break the rules." Waters wants to be startled by art. He is moved by what is beautiful, but he is clearly excited by the transgressive. The very best contemporary art, in his view, will of course outrage most viewers. It's not *suppposed* to look familiar. On some level, it *ought* to be inscrutable. Indeed, Waters is quick to suggest that it was his immersion in a world of diverse and often outrageous art forms that conditioned him to see *Pecker*'s positioning marks as a promising subject for his own camera.

HIT YOUR MARK, 1998
Six chromogenic prints
Checklist #38

Mel Bochner
Singer Lab Measurement (#4), 1968
Gelatin silver print, 10 x 8 in.
Courtesy of the artist and Sonnabend Gallery

In 2002 Waters began a new group of "drawings" derived from his personal file cards. He is a chronic and obsessively disciplined self-organizer; he plans literally *everything*. As a filmmaker, his schedule can be committed months or even a year in advance (and everything else will be erased from his schedule to accommodate the shooting schedule of his next movie). The file card is the primary tool he uses to maintain his program of hyperorganization. Waters has always used the file-card system (that is, he says, "I don't remember a time when I *didn't* use file cards"). He buys standard four-by-six blue-ruled white file (or index) cards; he uses one file card each day as a "day-minder." The night before, Waters makes notes by hand on one side of the card of everything he plans to do the next day relative to the outside world—telephone calls, errands, appointments. The "day card" is oriented horizontally and his notes are written on the horizontal. He uses the same file cards for other "to do" purposes, such as grocery lists, but those file cards are annotated in a vertical orientation.

The web of coded marks on the cards reflects the demands of Waters's hectic schedule. Items circled in red (or, sometimes, written in red ink) are the most urgent of the day—red means this task *must* be done before the end of that day. A check mark means that a task is only partially completed. For instance, Waters may have made the planned call but reached only an answering machine; the item cannot be crossed out until the call is returned and the business completed. The back of the file card, inscribed only vertically, is reserved for "footnotes" to the items on the face of the card. At the end of each day, Waters prepares a new file card for the next day. He reviews the present day's file card and carries over (that is, writes on the next day's card) any items not crossed out. He then throws away the completed day's card. The file card is so essential to Waters's functioning that he says he goes absolutely out of his mind when a card is misplaced, which doesn't happen often; but it has happened, and Waters exhibits tangible anxiety at the memory.

Sometime in the late 1990s, Waters started saving these daily file cards. At a certain point these patterns of crossed-out scribbles on tiny rectangles of ruled cards began to look like fragments of drawings to him. He formed the idea of using the cards as a work of art, initially imagining a collage of them as a wall installation in a room. In 2002 Waters began to focus on the "diary" aspect of the file cards and soon settled on a plan to take advantage of their calendrical nature. Working in his studio, he began to lay out file cards in various alignments. He researched the largest possible dimensions of mounting and framing materials for rectangular formats based on multiples of the four-by-six cards. He experimented with various degrees of photographic enlargement of the individual cards, but ultimately rejected that approach, opting to use the cards themselves as raw material.

At first Waters was frustrated by the geometric irregularities of the formats, which he initially based on multiples of weeks or months. The layouts generated under those constraints (three weeks, two months, whatever) left blank spaces in the rows. He couldn't make the layouts come out even. But once he gave up his self-imposed requirement to compose formats from a predetermined number

TEN CHANGE-OVER MARKS, 2003
Ten chromogenic print cut-outs
Checklist #73

TOP
SEIZURE, 2000
Seven chromogenic prints
Checklist #60

CENTER
BLACK AND WHITE CURTAINS, 2003
Seven chromogenic prints
Checklist #67

BOTTOM RIGHT
WRITER'S BLOCK, 2003
Six chromogenic prints
Checklist #76

of cards, he got where he wanted to be: days. Which meant that he had arrived at a place of abstraction in form and content alike. From that point of liberation, Waters was able to lay out rectangles of cards strictly from an aesthetic perspective, generating formats based on arbitrary numbers of days.

The formats of the file-card series (seven in all) were determined by the gallery space where the series was first exhibited in February 2003.[4] Using a scale model of the gallery, Waters tested various formats to decide which shapes and dimensions would work best in his installation plan for the show. Once that decision was made, he painstakingly selected cards, one by one, for each of the specified "drawings." The pool of cards was random. In any given drawing, cards from unrelated days and weeks and months and years are abutted willy-nilly, belying the calendrical subtext of the file cards. Waters laid them out based exclusively on the way they looked together. (He mostly rejected Saturday and Sunday cards, he says, because they tended to have too much white space on them; they simply did not enhance the overall design of the drawings.) Waters did not censor his selection to avoid revealing personal or sensitive information; he says he didn't even scan the cards for content before using them. In remembrance of things past, however, Waters reports that he felt exhausted just looking at the congested cards.

For a long time Waters envisioned presenting the file cards as drawings. He began to consider how best to mount and frame them and investigated various technical options. He had a studio assistant laboriously glue onto mat board a specified grid of cards for one of the designated formats so that he could spend time looking at the finished work before framing. The more Waters contemplated the result, the less satisfied he felt. The work didn't seem to be in harmony with his other photo-pieces. Skeptical as he was about the capabilities of photography to capture the necessary degree of detail, he consulted with experts in digital imaging and authorized test photography of one of the drawings. Setting framed versions of each model side by side—raw-material drawing next to photographed drawing—Waters knew

at once that the photo version was what he was after. He was delighted with the photographic quality made possible by digital technology. Not only were no details lost but the minutiae of the imagery actually seemed enhanced. The photographic medium for these works, Waters said at the time, was "more like me, it's what I do."

Not surprisingly, some viewers of the file-card pieces see Twombly's influence. Although Waters reveres Twombly's art, he doesn't see the relationship to his own work. His file cards are inscribed with real words, applicable to real life, directed to real actions, then obliterated for real purpose. Indeed, voyeurism is no small part of the appeal of these works. Viewers peer and squint at the imagery, trying to make out names and numbers. And the file cards feel so intimate! The original cards, after all, are handwritten, and handwriting today is unexpectedly personal, nearly quaint. (Waters not only doesn't use a computer, he doesn't even use a typewriter. He handwrites everything, including his scripts, books, lectures, and correspondence.)

Twombly makes marks that are entirely abstract, not derived from words or language or, for that matter, real life. Connoisseur Heiner Bastian describes Twombly's drawing as following a path that he calls "the temptation of writing." Bastian goes on to suggest that Twombly "disrupts the essence of drawing, he denies it its calling, the iconographic centre. He does not allow its meaning to extend into reality."[5] One could say that Twombly and Waters are working the flip sides of the same coin. Twombly, "tempted by writing," makes drawings that long to be read as words but never become legible. (Except to Waters, perhaps. He once quipped that he has spent so much time looking at Twombly's *Letter of Resignation* that he can "read Twombly's language.") In the file cards, conversely, Waters discovered "drawings" in what were once words, which he had obscured toward the illegible.

Even when Twombly "crosses out" his own marks (as in the 1967 *Letter of Resignation* drawings), he's not literally "crossing out." He's simply layering different "hands," variant types of marks, drawing over drawing. That's the unmistakable Twombly facture—abstraction at its purest. Waters's art, on the other hand, always tells a story; narrative, whether explicit or implicit, anchors the work's meaning and impact. Furthermore, appropriation is an integral part of Waters's photo-pieces. Most of his photographic works appropriate identifiable images from his own or other directors' movies, all shot off his television monitor at home. Through imaginative editing and witty conjunctions, Waters forges new stories and often transgressive "little movies" (as he calls them). For the *Marks* and file-card photos, Waters appropriated images from life rather than from art. These two groups of works, along with the photo-piece *Return to Sender* (2003), are anomalous in Waters's work. Nothing in *Mark #1–Mark #15* (or *Hit Your Mark*), the file-card pieces, or *Return to Sender* was shot off the monitor. The artist appropriated fragments from his own working life to create ostensibly abstract images in which explicit narrative is camouflaged.

Waters thinks of all these works as drawings, because he defines virtually all extra-linguistic mark-making as drawing. In that context, intention admittedly plays a significant role. An address on a

LEFT
Kurt Schwitters
Merz Drawing (Merzzeichnung), 1924
Collage of cut-and-pasted papers and a button, 7¾ x 6⅛ in.
The Museum of Modern Art, New York:
Katherine S. Dreier Bequest.
Digital image © The Museum of Modern Art, New York
© 2003 Artists Rights Society (ARS), New York/VG Bild-Kunst, Bonn

RIGHT
John Frederick Peto
Old Time Letter Rack, 1894
Oil on canvas, 30⅛ x 25 in.
Museum of Fine Arts, Boston,
Bequest of Maxim Karolik 64.411

RETURN TO SENDER, 2003
Durst Lambda digital print
Checklist #72

Cy Twombly
Letter of Resignation, Sheets X and XXVII, 1967
Sheet X: pencil, house paint on paper, 9¾ x 9¾ in.
Sheet XXVII: pencil, house paint, crayon on paper, 9¾ x 9¾ in.
Private Collection, USA
Courtesy of Zwirner and Wirth, New York

308 DAYS, 2003
Durst Lambda digital print
Checklist# 74

mailed envelope is language and is intended to direct the letter to the addressee. But an address on an envelope mailed to someone known to be dead or relocated (occasionally relocated to prison!) with the intention of getting the envelope returned with ad hoc postal annotations so that it can be collaged along with other such envelopes and photographed into a work of art? That's Waters's *Return to Sender,* and it can fairly be called conceptual drawing.

The idea came to him after he mailed his annual Christmas cards in 2001. Polly Bergen's was returned as undeliverable and, a bit later, so was Joey Heatherton's. The postal notes, rubber stamps, and imprints on the envelopes struck Waters as both funny and pathetic. He immediately knew he wanted to see more. So he went to the stationer's to select envelopes in a variety of colors and sizes— he already envisioned a collage of geometries, "my own version of Mondrian," he says. Waters artfully composed a series of envelopes, mostly hand-addressed, with different stamps (establishing a variegated palette, so to speak, for his future collage). He mailed the envelopes containing a single blank sheet of paper to famous, or infamous, people he knew to be deceased or not at the address indicated. Then he waited (patience not being Waters's strong suit), sometimes months, for the purposefully misdirected envelopes to come back. To his dismay, those for Andy Warhol and Jacqueline Kennedy never did get returned.

The look of *Return to Sender* recalls Mondrian less, perhaps, than the trompe l'oeil paintings of eighteenth- and nineteenth-century American painters such as Raphaelle Peale, William M. Harnett, and John Frederick Peto. *Return to Sender* is also somewhat reminiscent of the collage art of the Cubists, and on through Schwitters and Motherwell, in which fragments of newspaper and mailing labels appear as elements in abstract compositions. But Waters, characteristically, takes things a step further. He made the envelopes themselves both the concept and the composition, and he appropriated the postal service's often amusing or oddly inexplicable annotations on dead or "missing" celebrities as his subject. *Return to Sender* is one of Waters's most subversive works. Idea and image are one and the same. Seductively attractive, even classically modernist at a glance, the work is hilarious and pitiful and confounding when deconstructed.

Playful strategies—benign trickery, the sharing of secrets, droll deception, surreptitious co-opting of others as collaborators—underlie all of Waters's photographic works. He says he "tricked the post office into making drawings for me" (the marked-up returned envelopes of *Return to Sender*). He happily noticed that *Pecker* crew members were unknowingly making drawings for him as they placed the positioning marks. Most of the cross-outs on his daily file cards require the actions (or reactions) of others; hence, the patterns on each card are made with co-opted collaborators who know nothing of their participation. Just as Waters delights in appropriating imagery from the films of fellow directors in order to make new art from it, so he delights in appropriating the work of others (movie production crews, postal workers, business contacts, friends, and relations) to make surrogate drawings for him to photograph. At the same time, Waters now looks at his file cards in a brand new light: "I discovered I could draw," he says with glee. "I can't. But I did."

FACE-LIFT, 1996
Twenty-one chromogenic prints
Checklist #26

1. All statements by John Waters are from a conversation with the author at the artist's Baltimore studio on May 14, 2003.

2. *Mark #1–Mark #15* and its "pendant" *Hit Your Mark* were first exhibited at Gavin Brown's Enterprise, Corp., in association with American Fine Arts, Co./ Colin de Land Fine Arts, New York, June 18–July 31, 1998. Waters and his primary representative, the late Colin de Land (of American Fine Arts), decided that the *Marks* set, printed in an edition of five, could be broken up and the images sold individually. (It was later determined that at least one set of the edition would be kept intact.) *Hit Your Mark* is a single six-part photographic piece (its six images are matted and framed together in Waters's specified sequence from left to right), also printed in an edition of five. For a June 1998 interview with Waters focused on the *Marks* series, see Robert Thill, "John Waters: The Only Thing in a Movie Scene That You Are Not Supposed to See," *Transcript: A Journal of Visual Culture* (Duncan of Jordanstone College of Art, Dundee, Scotland) 3, no. 3: 119–28.

3. In 1991 Waters was invited to sit on the Board of Trustees of the Baltimore Museum of Art; for the duration of two consecutive three-year terms as a Trustee, he also sat on the Museum's Fine Arts Accessions Committee (chairing the Committee from 1993 to 1997), where he was a lively and well-informed participant in dialogues about contemporary art proposed for the collection. Waters's exposure to the workings of the museum and gallery world surely reinforced his interest in contemporary art and its institutions and personalities.

4. The file-card photographs were featured in the exhibition *John Waters: Hair in the Gate*, at American Fine Arts, Co./Colin de Land Fine Art, New York, February 21–March 22, 2003. The seven file-card pieces are *16 Days, 30 Days, 35 Days, 45 Days, 108 Days, 180 Days*, and *308 Days*. The three largest pieces (*108 Days, 180 Days, 308 Days*) were printed in editions of four; the others were printed in editions of eight. Waters still saves his daily file cards, in anticipation of using them to create future artworks, albeit of a yet-to-be-determined nature.

5. Heiner Bastian, *Cy Twombly: Letter of Resignation* (Munich: Schirmer-Mosel, 1991), unpaginated.

LEFT
30 DAYS, 2003
Durst Lambda digital print
44½ x 10 in.
Courtesy of American Fine Arts, Co./
Colin de Land Fine Art, New York

96

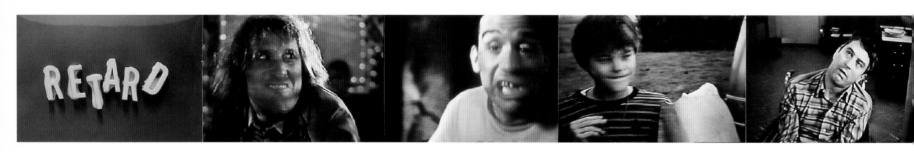

CENTER
RETARD, 2000
Ten chromogenic prints
Checklist #58

TOP
SULLEN COOKIE, 1998
Six gelatin silver prints
Checklist #49

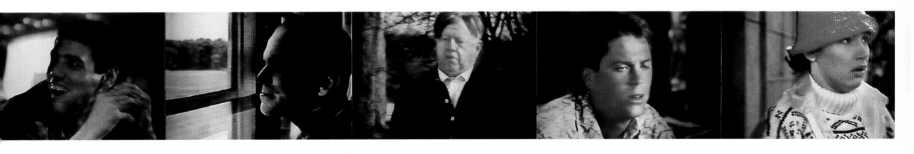

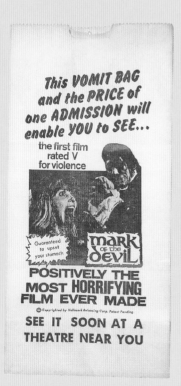

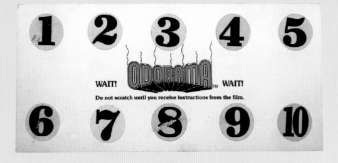

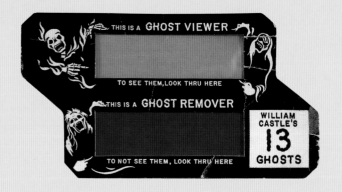

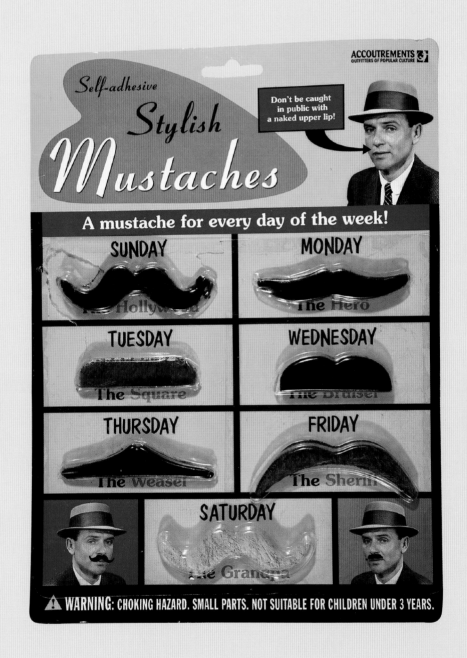

Attachable mustaches
from the personal collection
of John Waters

The Girls: Kim, Kathy, and *Tina,*
by John Waters from the personal
collection of John Waters

Magazine and plastic roach
from the personal collection
of John Waters

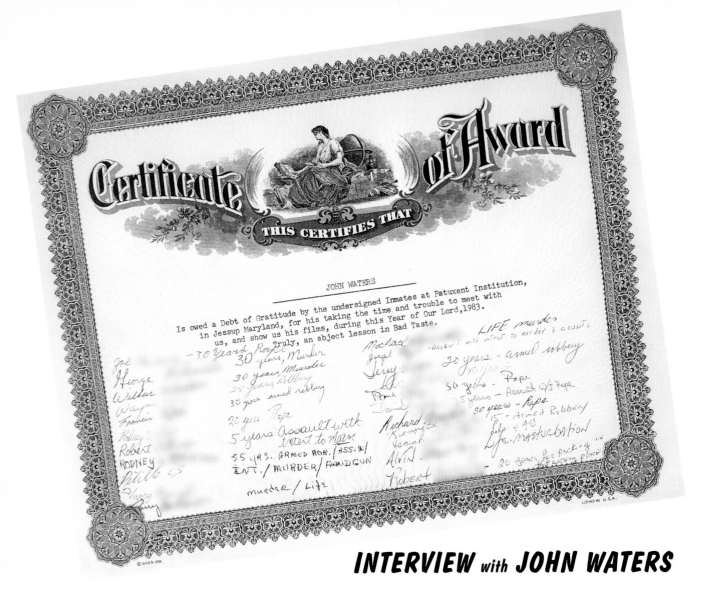

INTERVIEW with JOHN WATERS

Todd Solondz

JOHN WATERS Here we are, joined in art, at last. (Laughs)
TODD SOLONDZ Yes. Yes. You know, about twenty, twenty-five years ago in SoHo, there was a side of a building, visible to commuters driving back to New Jersey, that was used as an advertising space. And one day it was painted over in shocking pink, and against it in black script was written: "I never knew Art could be so much fun!" It was dripping with irony, a kind of mean, satirical jab, perhaps, at the bridge-and-tunnel crowd, of which I was a member, who flocked in each weekend to visit the super cool and super unfriendly galleries in Manhattan. Well, without irony, that painted sign flashes to mind when I think of your artwork.

JW Well, that's a compliment, whether you're talking about the photo shows or the movies.
TS I was thinking first of your photography, but I believe it applies overall.
JW Fun is a word that some people would tremble about in the art world. I asked Tom Friedman the same question when I interviewed him about his work: "Is it wrong to be fun in the art world?" And I think not. Certainly some of my pieces, if they're "fun," that's good. I didn't have fun when I made them, but I felt good about them. I hope the work has a little wit and humor in it, about the movie business, about how things are chosen, about how

"Professor of Bad Taste" award given
to John Waters by convicts on the
last day of his prison moviemaking
class at Patuxent Institution. From the
personal collection of John Waters

audiences conceive a movie. The art world has to appeal only to a tiny audience, a few people, and you and I both know we have to pretend, when we're raising money for our films, that they will appeal to everybody in the world. In the art business you never have to say that.

TS Nevertheless, when you walk out of a John Waters photography show you're not going to hear words like "lyrical" and "luminous."

JW There is art speak, probably, for the idea of fun. How about "rigorous stupidity and reworked pathos"? I love abstract art criticism because it's such a secret language.

TS The word "fun" isn't highbrow enough to apply and wouldn't quite get the kind of "respect" that these other terms get. But I read somewhere that you said, "I never would call what I do art."

JW It's always up to others to say if something is art. I hate it when people say, "I'm an artist." I think, well, I'll be the judge of that. And I don't think "artist" is a job description. It's a critique, a favorable critique, that someone else might apply to your work. I guess in the art world I'm not exactly a photographer, but I do use photography. I'm more of an editor in the art world, I think. I take chosen images and put them together in a certain way, and use photography. My work is rarely listed under photography, even in the art listings in magazines, because it's more about editing and writing.

TS So then would you call it editing and not art?

JW Well, look, if someone else calls it art...

TS But you can't, because it makes you cringe at the idea of...

JW Yes, if I say it, I'm giving myself a good review. You can say I make good art or bad art, but that has to be up to others. For me, the very word art is a good review. And to be honest, whether or not art lasts in any meaningful way is something that won't be known for twenty to thirty years.

One thing I have noticed in the art world, and this is a generalization, is that many of the dealers I know who like the most difficult, obscure kinds of artwork don't like art films. Very often the really edgy art dealers, artists, and art writers like really commercial movies. I'm always shocked by that.

TS Shocked and disappointed?

JW Oh, I'm never really disappointed if I'm shocked. But art movies are the kind I like the best. And that always seems to surprise people, because they think I'm going to like trashy movies, whatever that means anymore. Which

I guess I do. I like *Final Destination 2*, I like *Willard*.

TS So, as I understand it, what you're getting at is that your tastes range from the high to low ends but you run away from the middle ground.

JW I always have. I've said this before, but in shopping centers I feel like an old, suburban white lady in Watts in the middle of the riots. I'm terrified that somebody is going to stab me to death. When I hear terms like "mall-walking," I don't know what to do. I start trembling. I work really hard in life for one reason, so I never, ever have to be around the people who would get on my nerves. And that is success to me, being able to live your life so you just don't ever come in contact with the people you hate. And I almost never do anymore. I guess that means I'm successful.

TS Do you differentiate between your movie work and your artwork in terms of how each is made, or seen, as art?

JW They're completely different. I work on the photo pieces in a separate studio, because the photographic work is very separate in my mind. What I'm trying to do is not so different from one medium to the other, but it's a very, very different kind of theater.

I literally don't work on the photographic pieces and the films in the same building. I have never really given an interview about my art stuff in anything other than art or photography magazines.

I know that the one thing I will always have to overcome in the art world is skepticism about my movie celebrity. There's nothing I can do to change this. That's why, in my last show, I did a piece called *Self-Portrait #3* in which I nullified my celebrity by taking all my Greg Gorman head-shots and putting pushpins through them, and placing rubber roaches over my face and covering the retouched photos with blobs of white-out and rubber stamps that say "overexposed."

TS Right, but what you do is more than just make funny jokes. Mind you, it's no small achievement to make jokes that are funny.

JW The hardest thing of all, Todd. (Laughs)

TS Especially when it comes to art, jokes are not always intended to make people laugh. It's like what they say about stand-up: when it's funny you're a comedian, when you're not it's performance art.

JW (Laughs) Well, maybe. When I do my one-man show at colleges, if it works it's vaudeville, and if it doesn't it's a lecture.

ROSS HUNTER TURNS INTO DOUGLAS SIRK, 1994
Five chromogenic prints
Checklist #13

ROSS HUNTER TURNS INTO DOUGLAS SIRK

TOP
PYRO, 2003
Eleven chromogenic prints
Checklist #71

SCENE MISSING, 2000
Chromogenic print
Checklist #59

FIRE

SCENE MISSING

PYRO

TS The strange and funny thing about your artwork though is that even if I don't get something, I can still laugh. It touches a funny bone in some way, on an immediate level, before I can even start to intellectualize what's going on.

JW Well, that's good. Certainly there are some things, such as the titles, that help when you're looking at my work. They kind of explain the high concept, as they say in the movie business, of the piece. But it's all very, very personal. The work comes from my obsession with certain movies or experiences I've had, which you've had too, in the film business. It's about what happens in test screenings; it's about marketing, mistakes, and editing. It's about changing narrative by throwing in different images. That's all in there. It's very personal to me and I know it's there, but I don't know that the viewer always needs to know all that background information to enjoy looking at the work. Maybe "enjoy" is the wrong word.

TS To become engaged by it?

JW Yeah. Yeah.

TS There was a piece I saw in your recent show, *Return to Sender*, where you put together a collage of envelopes addressed and posted to old movie stars, and "Return to Sender" was stamped on each of them. And, well, it was funny. Very funny. But I also found it terribly poignant.

JW Well, I tricked the postman into doing art for me, into making drawings. Every one of the envelopes in that piece is a drawing, in its own way. To use art talk, there are gestures there, and you can see evidence of the mailman's hand movements. The idea for the piece started when I sent Polly Bergen a Christmas card and it came back with a notation on it that read: "Moved, Left No Address." And I thought, "Well, that's so rude." I love Polly, but it looked like she was escaping creditors or something. So then I started sending letters to different celebrities, even if I knew they were dead, at the last address I could find for them. And each letter would come back with completely different notations on it. Of course, I put my return address on the back, because I knew I was going to show the front of the envelopes and didn't want people to know where I live. I intentionally got different colored envelopes, knowing that I would lay them out and use them all in one piece. Many of the envelopes never came back. You could never tell which ones would. Andy Warhol's never came back. Jacqueline Kennedy's never came back. And I sent hers out three times in different envelopes, hoping. Lana Turner's didn't come back. And you have to wonder what happened to them. Do groupie postal workers steal them?

TS Looking at that piece was a rich and very moving experience for me. I got the sense of some lonely, demented fan, still

writing to his favorite stars, but so out of touch that he doesn't even realize that some of them are dead.

JW See, to me, it was the opposite in a way. It's about the loneliness of famous people, and how they have to move a lot for work. And when they move, their addresses are so public that anybody can find them. Famous people can never be sure they have privacy.

What's interesting is that the postmen even went to the effort of writing "Deceased" on some of them, including JFK Jr.'s. And then, as if the postal worker thought you might be stupid, he or she wrote the word "Died" under it, just in case you didn't know what "deceased" meant. That one really shocked me when it came back.

And the piece is also about how memory fades. There was one, sent to Charles Manson, that came back with "No Forwarding Order on File." I couldn't imagine Manson leaving a forwarding address with the post office after he left the Spahn Ranch for "Helter Skelter."

TS I got the sense that the postal workers were oblivious as to who these stars and famous people were, which added a bleakness to the whole endeavor. It's a brilliant piece, very resonant. As is *Straight*, which is a crooked photo of a Mel Gibson title card.

JW The image is actually framed crookedly. I know why I made it, but I want to hear your interpretation.

TS Well, Mel Gibson is not someone I imagine fund-raising for the GMHC. But he is something of an icon, a gay icon, perhaps, of a very attractive movie star who's straight. And I get a sense of anger and frustration from the piece, in one sense. But even more than that, I get a sense of hopelessness, a feeling that comes from the fact that he's represented by just his name in big letters, that he's become an abstraction.

JW Well, you see, that's a very good interpretation. And it's not exactly the reason I did it. At one time, Mel Gibson was quoted, in an interview published outside of this country, saying very anti-gay things. And so that was what I was thinking about: to frame his name and call it *Straight*, but have it be completely crooked.

TS And then play on the word "crooked"?

JW Yeah. Basically, I wanted to turn Mel Gibson into a lower-level Anita Bryant.

TS Close enough.

JW So to have just one little picture, a small picture, framed badly, crooked, and call it *Straight*, about somebody who is fairly well known as being very Catholic and very moral, well I guess that's a political piece. (Laughs)

TS At the end of the first book of your photographs, *Director's Cut*, you explain simply and directly the ideas and the thought processes behind each of your pieces, which I love.

JW I can do that with each piece. I've done it before, been a human Acoustiguide. Sometimes, for one night during the run of a gallery show, collectors are invited and I walk them through and tell them what I was thinking about when I made each piece. But that doesn't mean that's how I think they, or you, should see it.

TS One of the things I like about your work is that it's so

unpretentious, so free of trends and theory. No long, tedious explanations of obscure photographic processes. It's more like, "Hey, you can do this too. Just get a camera and…"

JW Well, you can. But you can't repeat the exact same shot. I've tried—it never works because of the chance involved. Yes, you can do what I do, but can you edit? That's the question. (Laughs)

TS Of course it's not quite so simple. But your spirit of generosity, the desire to be accessible and engaging, always comes through. It seems, in fact, to have transferred directly from your film work. Do you feel an obligation to be accessible? Because really, it's possible that your prestige level would increase if you weren't so accessible.

JW Well, I think there are many of my pieces that people could look at and go, "Huh?" For example, *Grace*

LEFT
STRAIGHT, 1996
Chromogenic print
3½ x 5 in.; 12 x 12 in. framed
Courtesy of American Fine Arts, Co./
Colin de Land Fine Art, New York

TOP RIGHT
DESPAIR, 1995
Five chromogenic prints
Checklist #15

Kelly's Elbows. Some people might ask, "Well, why shoot that?" And the reason I did is because I think she has beautiful elbows and nobody has ever mentioned that. Men always look at women and talk about their tits or their asses. Well, women's elbows can be beautiful too. So I'm just giving her elbows a good review. A lot of my work is about giving a good review to something that other people have forgotten or discarded. Or changing the plotlines of a movie that exists in my mind.

There's one piece in my last show called *Pyro*. It's a completely new narrative I made up about a guy being turned on by fire and fantasizing about naked firemen. But none of the pictures in *Pyro* were actually from that plot. The stills were from a variety of movies and were

DESPAIR

edited together to tell a new story, different from any of the stories the stills originally told. You might just look at it and say, "Oh, it's about a guy being turned on by fire." But that guy wasn't turned on by fire in the original movie he was in.

The obscurity in the work is something important too. I did a piece called *Secret Movie*. There's a sculpture pedestal, like they have in galleries, but it's incredibly thin and reaches almost all the way up to the ceiling. On top of it was a photograph of the title of one particular movie. It's a movie I like so much, but I don't want people to be able to see it, because if someone else liked it, it would be ruined. You know how it is when something you like gets discovered, and suddenly everybody loves something you've always stood for?

TS Yes.

JW Here the collector gets three different titles when he buys the piece; in case he gets me drunk and I reveal one of the titles, they've still got two left. (Laughs) The art world is full of secrets in a way. The more you learn how to see things in a new way, the more you learn the vocabulary, the more you get let in on those secrets. And I'm not against that. I find that kind of delightful. I made a whole movie about it, called *Pecker*. And overall the art world had a very favorable response to the film. A lot of people thought, "Oh, dealers are going to get pissed off when they see that movie." But they didn't at all! They said, "You knew what you were talking about." I mean, Pecker's story could have happened. It actually did happen with Ryan McGinley at the Whitney Museum. When I met him, he said, "I am Pecker." But there's a big difference. Pecker was naive.

TS Well, people don't get angry with you, in part because there's such a convivial spirit at work. Even when you're critical, it's all in fun.

I don't think anyone could ever accuse you of being mean-spirited or cruel toward your subjects.

JW I only make fun of things I love. That's true. The films I pick to photograph are films people assume I'm making fun of, because they were such failures or got no critical support when they were originally released. Like *Boom*, with...

TS Elizabeth Taylor. Yeah.

JW And Richard Burton. It's based on the Tennessee Williams play *The Milk Train Doesn't Stop Here Anymore*, and was universally panned when it came out—a famous art-movie failure. I just loved it. I always used this movie as a litmus test for future friends. Then I started to tour with it at the film festivals: "John Waters Presents *Boom*." And then I did a photo piece based on the movie that included the most obscure cutaway shots with no titles. So the only way you could identify the stills as being from *Boom* was if you were a real fan and could recognize every shot in the movie.

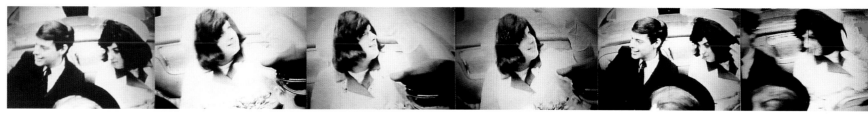

TOP
SECRET MOVIE, 2000
One chromogenic print on pedestal
Checklist #77

BOTTOM
ZAPRUDER, 1995
Twenty-four chromogenic prints
Checklist #23

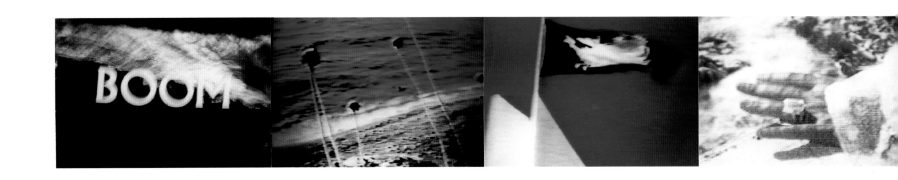

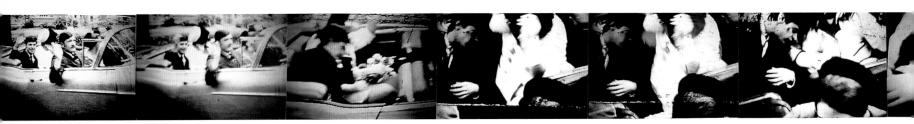

ZAPRUDER

TOP
BOOM!, 1998
Seven chromogenic prints
Checklist #36

RIGHT CENTER
FOREIGN FILM, 1994
Eighteen gelatin silver prints
Checklist #9

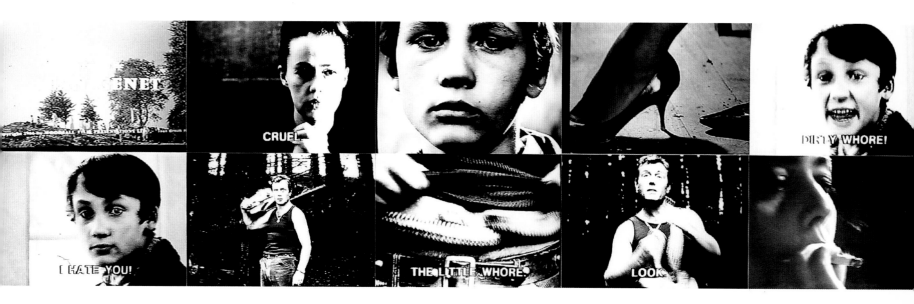

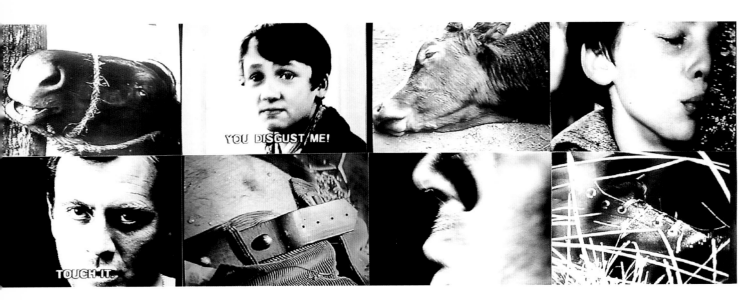

FOREIGN FILM

ZAPRUDER

Sceneggiatura e Regia di

IER PAOLO PASOLINI

I went even farther in my last show, *Hair in the Gate*. I had a replica made of the flag that Elizabeth Taylor flies in *Boom*. It's only on the screen for like a half a second, billowing in the wind, and you can't even see it. I had to take 100 pictures of it to get all the details. And then I had it fabricated in real life. If you just love a movie so much, if you like the props or the furniture in *Boom*, for example, you can have it all made. You can live in that movie if you're crazy enough to have everything made for you. You could eventually build the whole house that Elizabeth Taylor built in *Boom*. You could have the costumes made. You could walk around in that world and no one would know. You could be *Boom* yourself! (Laughs) And that to me is what cult audiences are about, fans who take things to a new level.

TS I have to say, I think it's really great that you're having this retrospective of your artwork.

JW They've talked me into showing my earliest films too, which in a museum context will probably be all right. In one little video room we're going to show *Hag in a Black Leather Jacket*, *Roman Candles*, and *Eat Your Makeup*, the movies I made as a kid, which no one's ever seen. The reason I think they'll work in the show is that, besides getting to see Divine when he's seventeen years old, people will be able to see the seeds of what interested me then, and still interests me now—Catholicism, my obsession with the press, assassins, race relations, shoplifting, obscure pop music, and taking scenes from other movies and using them. And the Kennedys. When we shot *Eat Your Makeup* in 1966, Divine played Jackie Kennedy and we re-created the complete Kennedy assassination. And years later, I did a photo piece called *Zapruder* with stills from my movie photographed off a TV monitor, which turned out so bad technically that they looked like they were from the real Zapruder film.

Recently, I read something that really amazed me. At exactly the same time we were making *Eat Your Makeup*, Warhol made a movie called *Since*, which has just been discovered. I've never seen it, but in it Ondine plays LBJ and Mary Woronov plays JFK. I don't think they're in the limo or anything like that, but the coincidence is amazing to me. Another Kennedy piece I did was about Jacqueline Kennedy, called *It*. There's a great shot of her with the biggest sunglasses paired with a photograph, from a horror movie trailer that says, "She has seen 'IT'." And that piece got to people; the first day it was shown, all the prints in the edition sold out, I guess because everybody wants to see IT, and basically everybody wants to be Jackie Kennedy.

Somebody once said that the snottiest thing I ever wrote—which was in an artist statement that I tried to have fun with and which was sent out as a press release for one of my shows—was that my work is really about the sadness normal people feel because they're not involved in show business. I didn't mean it to be snotty. But I do believe that every person who isn't in show business is a little depressed because they're not. People just go to work and come home feeling guilty about not being a movie star.

Even though you and I know how depressing it can be to be in show business! (Laughs)

TS Well, but isn't there that line that Jean Hagen gives in *Singin' in the Rain* where she says to her fans, "If we bring a little joy into your humdrum lives…"

JW I've always loved those kinds of people. They're the heroes of all my movies. I live in Baltimore for that reason, to be around not "little people," but people who lead completely normal lives, and who are, to me, sometimes the most insane of all. That's what always interests me.

PASOLINI, 1995
Four gelatin silver prints
Checklist #21

In the art world everyone thinks they're insane, but they're really normal. But the supposedly regular people have contempt toward contemporary art, which I find exciting.

I remember when I was about ten years old, I went to the Baltimore Museum of Art and brought home a little Miró print and hung it in my bedroom. And the kids who came over would say, "Oh, that's ugly!" "Horrible!" "That's hideous!" And I was thrilled! I thought, "Oh my god, art works. This is great! Art keeps away the morons!"

TS Well, the fact that you were able to look at it that way and have that sense of self-confidence…

JW Well, that's in hindsight. But I think I was secretly thrilled as a child at the ruckus art caused. I didn't take it down because the neighbor's kids hated it. No. I was defiant about it. (Laughs)

TS But that says something about your character, that you held on to your convictions. And it says something also about the way in which you grew up, about your family and your parents. There may be many misconceptions about you, but I think one thing that should be clear is that you in fact had a very supportive family without which you would not have been able to stand up for your convictions.

JW It's true. Even though, god knows, I had times growing up when my parents and I didn't get along. But it never got to the point where I became estranged from them. And I put them through many, many, many tests that most parents would have failed. I made these movies that were very public, that no one said were good for ten years. Local reviewers said I needed a psychiatrist and that the films were homosexual and drug-oriented, stuff my parents were, at first, just mortified by. I got arrested for shooting a scene for a movie that had a nude man in it, at Johns Hopkins University, where my father had graduated. He was furious!

But at the same time, they lent me the money to make those films. And I paid them back with interest. I look back on that now and see how loving they were. When I was a kid, I had a stage built in our house for me. (Laughs) That's really embarrassing to admit. And later Divine, in *Female Trouble*, has a little stage built for her. I was lucky. My parents tolerated my exhibitionism. Even when I was a young kid I knew the direction I was going in.

TS I'm very impressed that your parents have endured all that you threw at them.

JW Endured is a good word.

TS I mean, if you had been born twenty years later it wouldn't have been quite so shocking, given the way things and times have changed.

JW My mother says that now too. When *Hairspray* became a big hit on Broadway and all these people, her peers, were saying, "Oh, you must be so proud," she said, "Some of them are the same people who, when you were young and making those movies, mentioned your brothers and sisters but wouldn't mention your name, as if you were dead." I remember too. She remembers that she used to get mean reviews or articles about me mailed to her anonymously.

TS Now that's hard, although it's probably easy to laugh about it now.

JW She isn't laughing about it. (Laughs) But I like the fact that she remembers and says it. She doesn't have complete revisionist thinking. However, you know, my early movies still horrify them. My parents never saw *Pink Flamingos*. The only time in recent years I've had a fight with my parents was over the piece *Twelve Assholes and a Dirty Foot*.

TS Mm-hm.

JW I told them I wanted to dedicate my book *Director's Cut* to them, and they said, "Oh, that's nice. We'd love that." But I said, "I've got to tell you, there's one piece in there that's really obscene." They said, "Oh, nothing you do could shock us anymore." And I'm thinking, "Well…"

BIRTH CONTROL, 2003
Eighteen chromogenic prints
Checklist #66

(Laughs) So I gave them the book and I even taped those pages shut, and they never said a word. Which really is the way my family can get on my nerves, by just not saying anything. You know, denial. The "d" of denial should be our family seal. So I said, "Well, what did you think of the book?" And mom, furious, said, "WELL, WE WERE APPALLED! WHY WOULD YOU DO SOMETHING LIKE THAT? WHY? JUST WHY?"

Later, I said to myself, "What did you expect? You hand your parents a book and expect them to sit on their sofa in Baltimore and look at pictures of men's assholes? Are they supposed to say, 'That's nice'?" But I guess that's part of why I made it. When that piece was in the gallery, I overheard a normal-looking straight couple, a man and a woman, who were sitting there looking at it. And the man said to the woman, very seriously (I guess it wasn't their first date), "You know, I've never seen my own asshole." And I thought, "Aha, you see? Art really brings out the most intimate conversation." But the woman said nothing. She looked stupefied and offended that he had said that. But what was she supposed to say? "Me either," or "I have"?

TS But the thing that's so charming about that piece is the fact that there's a curtain so you can choose whether or not to cover the picture up.

JW Well, it's about censorship, you know, the kind we both have experienced.

TS Yeah, yeah, yeah, yeah.

JW You had a big red curtain in your movie *Storytelling*.

TS (Laughs) Yeah. But I just love the discretion and good taste of the piece, the fact that even your parents could have it in their home, if they just keep it covered up.

JW Well, maybe that's what, figuratively, parent-child relationships are about in a way. (Laughs) I have a cover over me in certain areas. They'd rather see *Hairspray* than *Twelve Assholes and a Dirty Foot*. But I think by now they are fairly used to my personality and interests. They don't

expect any big changes. My mother recently said to me, "Your next movie, it's going to be about sex addicts, right? Is that going to ruin all the great critical reaction you've had from *Hairspray*, the musical?" And I said, "Yeah." (Laughs)

TS Do you think your parents have a sense of humor about things at this point, after everything you've put them through?

JW Yes, and they always have. That's how we've survived. And I believe humor is how we all survive.

TS I feel the same way. Life is just so hard to endure as it is. If you can't laugh, you're really doomed.

JW If you can't laugh, and there are some people who can't, it's a life sentence of hell. You've got to be able to laugh about yourself first. And then almost anything is tolerable. And if you can't, you generally age badly.

116

BIRTH CONTROL

TOP
HAIR IN THE GATE, 2003
Seven Durst Lambda digital prints
Checklist #68

CENTER
EAT YOUR MAKEUP, 1996
Seven gelatin silver prints
Checklist #25

STARRING
MALLCUM SOUL
DAVID LOCHARY

and introducing
MARINA MELIN

produced, directed,
written & filmed
by
JOHN WATERS

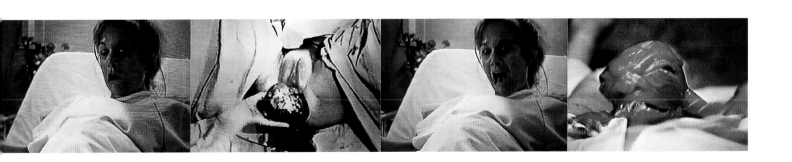

Starring Mary Vivian Pearce and Mona Montgomery, this was Waters's first film, made on the roof of his parents' home while he was a senior in high school. The film opens with a young woman (Mona Montgomery) home alone. She watches as a black man drives up with a garbage can in the front seat of his car. She rides off with him, strips down to a black leotard, ties up her ballet slippers, and then dances. The black man watches her from the car then joins her outside and begins to dance. He then removes the garbage can from the car and climbs into it. The woman hefts the garbage can into the car and drives away. Meanwhile, a Klansman is perched on a chimney of a house. The young woman, dressed in a bridal gown, the black man, and various other characters dressed in early-Pop-influenced outfits join him on the roof for a wedding ceremony. The groom tosses the cake onto the roof of the car below. The party climbs down and eats cake, using the car doors as seats. The wedding party drives off, the Klansman seated on the hood, wearing a cross. At the end, Mary Vivian Pearce dances the "bodie green," an obscene bump-and-grind, as Waters's mother plays "God Bless America" purposely off-tune on the piano off screen. The final frames show a piece of paper with "The End" written on it being flushed down a toilet. Never commercially released, the film was only shown once in public, at a Baltimore coffeehouse. It was filmed on stock that had been stolen by Mona Montgomery, who worked in a camera shop.

Stills from
HAG IN A BLACK LEATHER JACKET, 1964
Checklist #82

Stole, *Roman Candles* is a montage of seemingly random incidents involving sex, drugs, and religion. Influenced by Andy Warhol's *Chelsea Girls,* the short film was originally shown using three projectors running simultaneously, with a tape recording of radio advertisements, nostalgic pop music, and a press conference with Lee Harvey Oswald's mother. When Waters transferred the film to videotape for the current exhibition, he chose to divide the screen into four quadrants, leaving one blank. Many of the scenes were filmed in Waters's bedroom in his parents' home, and they include a nun (Maelcum Soul) making out with a priest, a woman (Mary Vivian Pearce) being attacked by an electric fan, a bride (Mona Montgomery) whipping a man, and Divine playing hide-and-seek. This was the first film produced under the name Dreamland Studios and it premiered at a local Episcopal church.

Stills from
ROMAN CANDLES, 1966
Checklist #83

the story of a disturbed couple (David Lochary and Maelcum Soul) who kidnap three models (Marina Melin, Mary Vivian Pearce, and Mona Montgomery) and chain them in the woods. While an audience of their party guests gathers, the young women are forced to eat makeup and model themselves to death. Highlights include the opening scene where a woman in torn rags (Berenika Cipkus) crawls across a sand dune, moaning and muttering "makeup." She finally crosses the dunes and begs a man for makeup. He gives in and throws a selection of makeup on the sand, which she eagerly devours. Then he attaches a dog collar and leash to the woman. Another early scene follows the wicked couple and a vicious dog as they stalk a model (Marina Melin) who has just emerged from church fingering her rosary beads and repeating her "Hail Mary" prayer. Later in the film, while looking through fashion magazines, Divine begins to fantasize she is Jackie Kennedy. She and JFK (Howard Gruber) ride in an open car, and, as the music builds, a shot is fired. Released only two years after the event, this reenactment of the Kennedy assassination was considered especially tastelessat the time. The movie ends with the death of one of the models on the runway. The partygoers disappear, leaving the dead woman. She miraculously awakens, wearing a fairy princess dress and tiara and carrying a magic wand, after being kissed by a dirt-ball Prince Charming. Shot on Waters's parents' front lawn with a newly purchased 16mm silent camera, the film was screened only once at a local church. Dreamland star Maelcum Soul died a few months later.

Stills from
EAT YOUR MAKEUP, 1967
checklist #84

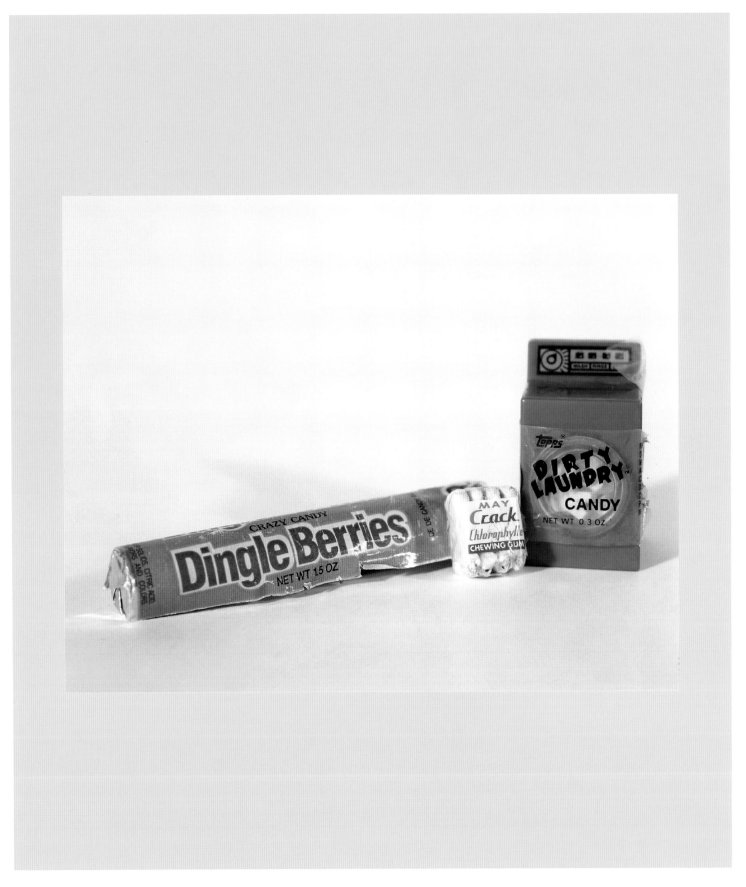

Vintage candies from the personal
collection of John Waters

JOHN WATERS: CHANGE OF LIFE
WORKS IN THE EXHIBITION
with comments by John Waters
*Dimensions are given in inches;
height precedes width.*

PHOTOGRAPHS

1. A COLD WIND, 1992
Four chromogenic prints,
3½ x 5 in. each, 12⅝ x 15⅝ in. *(framed)*
Image: 7 x 10 in. Edition of 8
Collection of Emily Apter and Anthony Vidler

Drink. Have fun. Die. The End.
"High Concept" goes arty.

2. DIVINE IN ECSTASY, 1992
Chromogenic print,
10 x 13 in., 16⅛ x 20⅛ in. *(framed)*
Image: 10 x 13 in. Edition of 8
Collection of Zachary and Amy Lehman

One glorious second between rape
and Catholic sainthood.
Divine goes to heaven.

3. GOSSIP, 1992
Two chromogenic prints,
3½ x 5 in. each, 7⅛ x 13⅝ in. *(framed)*
Image: 3½ x 10 in. Edition of 8
Collection of Todd Oldham and Tony Longoria

Edie pisses off Divine.
All my early films pitched
in just two single shots.

4. SLADE 16, 1992
Sixteen chromogenic prints,
3½ x 5 in. each, 7⅛ x 85¼ in. *(framed)*
Image: 3½ x 81½ in. Edition of 8
Courtesy of the artist

You fall in love as a teenager, get pregnant,
and have an illegitimate child. Then your baby
catches on fire and your boyfriend puts it out;
presto—a happy ending.

5. TRUE CRIME #2—SCRAMBLEHEAD, 1992
Six chromogenic prints,
3½ x 5 in. each, 16¾ x 17⅞ in. *(framed)*
Image: 10 x 10½ in. Edition of 8
Private Collection

Manson robot. Brainwashed. Murderous.
Bad teeth. Cute.
Villains are always the best part.

6. MANSON COPIES DIVINE'S HAIRDO, 1993
Two chromogenic prints,
5 x 7 in. each, 20⅛ x 16⅛ in. *(framed)*
Image: 10 x 7 in. Edition of 8
Collection of Nan Goldin

Without knowing it, Manson pays homage
to *Pink Flamingos* and loses the battle
for the "filthiest person alive."

7. PEYTON PLACE—THE MOVIE, 1993
Sixteen chromogenic prints,
3½ x 5 in. each, 7⅛ x 83½ in. *(framed)*
Image: 3½ x 79½ in. Edition of 8
Collection of George Stoll

Cutaway shots stand in for sex, '50s style;
frigidity, orgasm, incest, and rape
(Hollywood abstract).

8. BAD SEED, 1994
Nine chromogenic prints,
3½ x 5 in. each, 7⅛ x 48½ in. *(framed)*
Image: 3½ x 44⅝ in. Edition of 8
Collection of Todd Oldham and Tony Longoria

One evil second from my childhood
heroine's "big shocker." I wanted to be her.
I still do.

9. FOREIGN FILM, 1994
Eighteen gelatin silver prints,
3½ x 5 in. each, 12⅝ x 50¾ in. *(framed)*
Image: 7 x 44⅞ in. Edition of 8
Collection of Mr. & Mrs. Bernard L. Shaw

Genet. Moreau. Masochism. Lick the boots,
poison the animals, worship the buckle.
Forget the filler, get to the good parts.
Subtitles equal sex!

10. INGA #1, 1994
Six chromogenic prints,
5 x 7 in. each, 37¼ x 13¾ in. *(framed)*
Image: 29¾ x 7 in. Edition of 8
Courtesy of American Fine Arts, Co./
Colin de Land Fine Art, New York

When a Swedish art film meant dirty,
the way it should be.

11. LANA BACKWARDS, 1994
Eight chromogenic prints,
5 x 7 in. each, 11⅜ x 63 in. *(framed)*
Image: 5 x 56¼ in. Edition of 8
Collection of Todd Oldham and Tony Longoria

Show the outfit, see the ass,
worship the ultimate star one second longer
than usual. Leaving the room never looked
so sexy. To hell with entrances.

12. PEYTON PLACE—THE DOCUMENTARY, 1994
Sixteen chromogenic prints,
3½ x 5 in. each, 7⅛ x 83½ in. *(framed)*
Image: 3½ x 79⅜ in. Edition of 8
Private Collection

Write a bestseller, leave your husband,
move to New York, become a drunk and die.
Grace Metalious,
my own personal literary saint.

13. ROSS HUNTER TURNS INTO DOUGLAS SIRK, 1994
Five chromogenic prints,
5 x 7 in. each, 11⅜ x 41⅜ in. *(framed)*
Image: 5 x 35 in. Edition of 8
Collection of Todd Oldham and Tony Longoria

A legendary Hollywood hack meets
the ultimate auteur—
dead center of a famous dissolve.

14. SELF-PORTRAIT, 1994

Ten chromogenic prints,
3½ x 5 in. each, 7⅛ x 53½ in. *(framed)*
Image: 3½ x 49¾ in. Edition of 8
Collection of Brenda Potter and Michael Sandler

**Low self-esteem. Some days I pretend
I'm Don Knotts all day long.**

15. DESPAIR, 1995

Five chromogenic prints,
3½ x 5 in. each, 7¼ x 28¾ in. *(framed)*
Image: 3½ x 25 in. Edition of 8
Collection of Ben Stiller

**The final humiliation
of a disastrous film experience—
Director's Guild of America style.**

16. DIVINE IN PRAYER, 1995

Six gelatin silver prints,
8 x 10 in. each, 16¾ x 55 in. *(framed)*
Image: 10 x 47½ in. Edition of 8
Collection of Pamela and Arnold Lehman

**A spiritual reaching out—
Hallmark meets Dreamland on Easter.**

17. DOUBLES, 1995

Two chromogenic prints,
3½ x 5 in. each, 7¼ x 13¾ in. *(framed)*
Image: 3½ x 10 in. Edition of 8
Collection of Constance R. Caplan, Baltimore

**Elizabeth Taylor gets in drag
to become Divine.**

18. EDITH TELLS OFF KATHARINE HEPBURN, 1995

Two chromogenic prints,
3½ x 5 in. each, 8¾ x 11 in. *(framed)*
Image: 5 x 7¼ in. Edition of 8
Collection of Vincent and Shelly Fremont

The toothless berate the humorless.

19. LEADER, 1995

Eight gelatin silver prints,
3½ x 5 in. each, 7¼ x 43¾ in. *(framed)*
Image: 3½ x 40 in. Edition of 8
Private Collection

**Ultimate classic film sequence;
altered, glamorized,
and given a new ending.**

20. OTTO, 1995

Eight chromogenic prints,
5 x 7 in. each, 11¾ x 63 in. *(framed)*
Image: 5 x 56 in. Edition of 8
Collection of Elizabeth Lecompte

**Director best remembered
for his meanness to movie stars begins Jean
Seberg's tragic journey to the car trunk.**

21. PASOLINI, 1995

Four gelatin silver prints,
3½ x 5 in. each, 7¼ x 23½ in. *(framed)*
Image: 3½ x 19¾ in. Edition of 8
Collection of Jim Jarmusch

**Pimples.
Rough trade Christ.
A holy card for the damned.**

22. WILLIAM CASTLE, 1995

One chromogenic print and one gelatin silver print
5 x 7 in. each, 11¾ x 20¾ in. *(framed)*
Image: 5 x 14 in. Edition of 8
Collection of Todd Oldham and Tony Longoria

Maybe Hitchcock was the copycat.

23. ZAPRUDER, 1995

Twenty-four chromogenic prints,
3½ x 5 in. each, 1st section: 7⅛ x 86½ in.;
2nd section: 7⅛ x 36⅜ in. *(framed)*
Images: 3½ x 84½ in. (1st section);
3½ x 36½ in. (2nd section). Edition of 8
Collection of Jean Stein

**Divine is Jackie Kennedy;
then, now, forever.**

24. DOROTHY MALONE'S COLLAR, 1996

Ten chromogenic prints,
5 x 7 in. each, 11¾ x 77¼ in. *(framed)*
Image: 5 x 69½ in. Edition of 8
Collection of Carl Ehrhardt and Elizabeth Hazen

**An entire career told through
a signature costume affectation.**

25. EAT YOUR MAKEUP, 1996

Seven gelatin silver prints,
3½ x 5 in. each, 7¼ x 38¾ in. *(framed)*
Image: 3½ x 35 in. Edition of 8
Collection of Patricia Gidwitz

**Sometimes credits
are the only things that count.
Go ahead, model yourself to death.**

PEYTON PLACE—THE DOCUMENTARY, 1994
Sixteen chromogenic prints
Checklist #12

26. FACE-LIFT, 1996

Twenty-one chromogenic prints,
3½ x 5 in. each, 1st section: 7⅛ x 102½ in.;
2nd section: 7½ x 7⅛ in. *(framed)*
Image: 3½ x 100½ in. (1st section);
3½ x 5 in. (2nd section). Edition of 8
Collection of Susan and Michael Hort

**Elizabeth Taylor's cosmetic stitches
inspire John Waters's mustache.
All you need is a look.**

27. I, MARY VIVIAN PEARCE, 1996

Thirteen gelatin silver prints,
5 x 7 in. each, 9¾ x 95¾ in. *(framed)*
Image: 5 x 90¾ in. Edition of 8
Collection of James A. Mounger

***I, A Woman* meets *Multiple Maniacs*—
the ultimate female sexploitation pose.**

28. LIZ TAYLOR'S HAIR AND FEET, 1996

Hair: twenty-six chromogenic prints, 5 x 7 in. each;
feet: seven chromogenic prints, 5 x 7 in. each
Hair: 39¾ x 49¼ in.; feet: 5⅛ x 49¼ in. *(framed)*
Image: 39 x 48½ in. (hair); 4½ x 48½ in. (feet)
Edition of 8
Collection of Patricia Gidwitz

So famous, you don't need a face.

29. MOVIE STAR JESUS, 1996

Eighteen chromogenic prints,
3½ x 5 in. each
Vertical section of cross: 46¾ x 8¾ in.;
horizontal section of cross: 7¼ x 38¾ in. *(framed)*
Image: 42½ x 5 in. (vertical section);
3½ x 34¾ in. (horizontal section). Edition of 8
Collection of Ross Bleckner

**Erotic, S&M inspiration celebrated
with astonishment.**

30. SEVEN MARYS, 1996

Seven chromogenic prints,
5 x 7 in. each, 11¾ x 56¼ in. *(framed)*
Image: 5 x 49 in. Edition of 8
Collection of Jo Andrews and Steve Buscemi

**Baby Jesus' mothers meet one famous
mailbox. Oh, Mary. Hail Mary.**

31. TRUE CRIME #1, 1996

Four chromogenic prints,
5 x 7 in. each, 11¾ x 34¾ in. *(framed)*
Image: 5 x 27½ in. Edition of 8
Courtesy of American Fine Arts, Co./
Colin de Land Fine Art, New York

**Kate Millet's child-murdering heroine
of *The Basement* is released from prison after
decades of cosmetology lessons.
Free at last! Free at last!**

32. TWELVE ASSHOLES AND A DIRTY FOOT, 1996

Thirteen chromogenic prints with velvet curtains,
5 x 7 in. each; curtain: 22 x 139 in., 9¾ x 96¼ in. *(framed)*
Image: 5 x 91 in. Edition of 4
Courtesy of Rena Bransten Gallery, San Francisco

**Where the sun don't shine; censorship,
taboos, and self-awareness.**

33. ANN-MARGRET, 1997

Five chromogenic prints,
3½ x 5 in. each, 7¼ x 28¾ in. *(framed)*
Image: 3½ x 25 in. Edition of 8
Collection of Estelle Schwartz, New York

***Kitten with a Whip*—three eyes
and an attitude.**

34. MOVIE STAR JUNKIE, 1997

Eight chromogenic prints,
9¼ x 12⅛ in. each, 16 x 103¾ in. *(framed)*
Image: 9¼ x 97 in. Edition of 8
Collection of Johnny Depp

**Minimalist holes of cinematic seriousness.
All actors yearn to play drug addicts.**

35. BIG MONDAY, 1998

Chromogenic print,
16 x 24 in., 23 x 30¾ in. *(framed)*
Image: 16 x 24 in. Edition of 8
Collection of Todd Oldham and Tony Longoria

**The weekend grosses are in. Does
the picture hold? What film could be so low
to only play on Monday?**

36. BOOM!, 1998

Seven chromogenic prints,
3½ x 5 in. each, 7¼ x 38¾ in. *(framed)*
Image: 3½ x 35 in. Edition of 8
Collection of Eileen and Peter Norton, Santa Monica

**The ultimate cutaways for the elitist
Joseph Losey enthusiast.**

37. GRACE KELLY'S ELBOWS, 1998

Eight chromogenic prints,
5 x 7 in. each, 11¾ x 62¾ in. *(framed)*
Image: 5 x 56 in. Edition of 8
Collection of Robert R. Littman and Sully Bonnelly

**Zeroing in on a woman's beauty—
fetish style.**

38. HIT YOUR MARK, 1998

Six chromogenic prints,
9 x 13¾ in. each, 15 x 89⅜ in. *(framed)*
Image: 9 x 83½ in. Edition of 5
Courtesy of American Fine Arts, Co./
Colin de Land Fine Art, New York

**A triumphant "still" that would never
be in any press package.**

PEYTON PLACE: THE DOCUMENTARY, 1994

BIG MONDAY, 1998
Chromogenic print
Checklist #35

39. IN MY HOUSE series, 1998

At Home; *In My Dishwasher*;
In My Freezer;
In My Private Files; *Under My Sink*;
Under My Bed; *In My Car*; *In My Video Closet*;
Under My Covers with Me; *In My Mind*
Ten chromogenic prints,
16 x 20 in. each. Edition of 5
Courtesy of American Fine Arts, Co./
Colin de Land Fine Art, New York
and Collection of Todd Oldham and Tony Longoria

Snooping on yourself in your own home can really be revealing.

40. JAYNE, 1998

Three chromogenic prints,
3½ x 5 in. each, 7¼ x 18¾ in. *(framed)*
Image: 3½ x 15 in. Edition of 8
Collection of Kim Hastreiter

Spontaneous combustion. Only she had the power.

41. MANSON COPIES DOROTHY MALONE'S COLLAR, 1998

Two chromogenic prints,
5 x 7 in. each, 11½ x 20½ in. *(framed)*
Image: 5 x 14 in. Edition of 8
Collection of Bob Ritner

So evil, so unoriginal.

42. MARK #1–MARK #15, 1998

Series of fifteen chromogenic prints,
14 x 19¾ in. each, 20⅜ x 25⅝ in. *(framed)*
Image: 14 x 19¾ in. Edition of 5
Courtesy of American Fine Arts, Co./
Colin de Land Fine Art, New York
and Collection of Todd Oldham and Tony Longoria

The grips on the set of *Pecker* made me drawings on the floor without even knowing it.

43. MENTAL, 1998

Nine chromogenic color prints, 5 x 7 in. each
1ˢᵗ section: 10¾ x 59 in.;
2ⁿᵈ section: 10¾ x 9¾ in. *(framed)*
Image: 5 x 56 in. (1ˢᵗ section); 5 x 7 in. (2ⁿᵈ section)
Edition of 8
Collection of Mayer Rus

Scenery-chewing with the glamour girls. Too big for one wall!

44. PIMPLES, 1998

Eight chromogenic prints,
5 x 7 in. each, 11¾ x 62¾ in. *(framed)*
Image: 5 x 56 in. Edition of 8
Courtesy of Arthur Roger Gallery, New Orleans

What makeup people are paid to cover. The first "kill" of a movie star's publicity campaign.

45. PLEASE GOD, 1998

Chromogenic print,
3½ x 5 in., 7⅛ x 8⅝ in. *(framed)*
Image: 3½ x 5 in. Edition of 16
Private Collection

Everybody has a bad day.

46. PUKE IN THE CINEMA, 1998

Ten chromogenic prints,
5 x 7 in. each, 11¾ x 76¾ in. *(framed)*
Image: 5 x 70 in. Edition of 8
Collection of Nancy and Joel Portnoy

Action! A special effect that *always* delivers.

47. SONNY FOR PRESIDENT, 1998

Five chromogenic prints,
3½ x 5 in. each, 7¼ x 28¾ in. *(framed)*
Image: 3½ x 25 in. Edition of 8
Courtesy of American Fine Arts, Co./
Colin de Land Fine Art, New York

Sometimes, a hairdo *is* enough.

48. SOPHIA LOREN DECAPITATED, 1998

Six torn chromogenic prints,
8 x 10 in. each, 14¾ x 66½ in. *(framed)*
Image: 8 x 60 in. Edition of 8
Courtesy of Pamela Markham Heller

Stalkers—the downside of celebrity.

49. SULLEN COOKIE, 1998

Six gelatin silver prints,
5 x 7 in. each, 11¾ x 48¾ in. *(framed)*
Image: 5 x 42 in. Edition of 8
Collection of Perry Pater Dallas

Before Nan Goldin, still in Baltimore. Divine's "daughter" forever.

50. THREE SIRK MIRRORS, 1998

Three chromogenic print cut-outs
14 x 26 in. *(framed)*. Image: 7 in. diam.
(1ˢᵗ oval); 5 in. diam. (2ⁿᵈ oval); 3½ in. diam. (3ʳᵈ oval)
Edition of 8
Collection of Nayland Blake

Discover, isolate, take home, and make your own. There's no such thing as a bad movie.

51. BUCKLE UP, 2000

Fourteen chromogenic prints,
5 x 7 in. each. 1ˢᵗ section: 8¾ x 92¾ in.;
2ⁿᵈ section: 8¾ x 9¼ in. *(framed)*
Image: 5 x 91 in. (1ˢᵗ section); 5 x 7 in.
(2ⁿᵈ section). Edition of 8
Courtesy of American Fine Arts, Co./
Colin de Land Fine Art, New York

Fear of flying, movie style.

52. CLARABELLE, 2000

Two chromogenic prints,
8 x 10 in. each, 14¾ x 26¾ in. *(framed)*
Image: 8 x 20 in. Edition of 8
Collection of Janice and Mickey Cartin

The ultimate psycho; aggressive, violent, and ready to squirt your child with seltzer water.

53. CONDEMNED, 2000

Four gelatin silver prints,
5 x 7 in. each, 8¾ x 31¾ in. *(framed)*
Image: 5 x 28 in. Edition of 8
Collection of Richard D. Marshall, New York

The Catholic Church, Tennessee Williams, Archbishop "Kitty" Spellman— my first inspiration.

54. FARRAH, 2000

Eight chromogenic prints with cut-outs,
8 in. x various widths ranging from 10 to 11¾ in.
16¼ x 96¼ in. *(framed)*
Image: 9½ x 88¾ in. Edition of 8
Collection of Robert R. Littman and Sully Bonnelly

**Everybody looks better
with the most famous hairdo in the world.**

55. IT, 2000

Two chromogenic prints,
9½ x 14 in. each, 16¼ x 34¾ in. *(framed)*
Image: 9½ x 28 in. Edition of 8
Collection of Vincent and Shelly Fremont

Jackie Kennedy *is* God!

56. JULIA, 2000

Two chromogenic prints,
5 x 7 in. each, 8¾ x 17¾ in. *(framed)*
Image: 5 x 14 in. Edition of 8
Collection of Pamela and Arnold Lehman

**What is beauty?
Each decade decides differently.**

57. MANSON COPIES RICHARD GERE, 2000

Two chromogenic prints,
5 x 7 in. each, 8¾ x 17¾ in. *(framed)*
Image: 5 x 14 in. Edition of 8
Collection of Linda O'Keeffe

**Charlie's parole hearing
suddenly goes upscale. Maybe they used
the same stylist.**

58. RETARD, 2000

Ten chromogenic prints,
5 x 7 in. each, 8¾ x 73¾ in. *(framed)*
Image: 5 x 70 in. Edition of 8
Courtesy of Aurthur Roger Gallery, New Orleans

Oscar-bait never looked so silly.

59. SCENE MISSING, 2000

Chromogenic print,
16 x 24 in., 22¾ x 30¾ in. *(framed)*
Image: 16 x 24 in. Edition of 8
Collection of Nancy and Joel Portnoy

Editing. Loss. Divorce. Death.

60. SEIZURE, 2000

Seven chromogenic prints,
8 x 10 in. each, 14¾ x 76¾ in. *(framed)*
Image: 8 x 70 in. Edition of 8
Courtesy of American Fine Arts, Co./
Colin de Land Fine Art, New York

**Japanese school children
had epileptic fits from exposure to bad
imitation Rothko paintings.**

61. SELF-PORTRAIT #2, 2000

Five chromogenic color prints,
8 x 10 in. each, 14¾ x 56¾ in. *(framed)*
Image: 8 x 50 in. Edition of 8
Collection of Tama Janowitz and Timothy Hunt

**Marketing John Waters—
a match made in hell.**

62. STRAIGHT TO VIDEO, 2000

Chromogenic print,
1 x 1⅜ in., 20¼ x 18¼ in. *(framed)*
Image: 1 x 1⅜ in. Edition of 8
Private Collection, New York

**Ultimate "wrap party" present
from a star to their director after
a disastrous movie shoot.**

63. TOILET TRAINING, 2000

Nine chromogenic prints,
5 x 7 in. each, 8¾ x 66¾ in. *(framed)*
Image: 5 x 63 in. Edition of 8
Collection of Nancy and Joel Portnoy

**All serious actors seem to think
this shot proves their commitment
to their craft.**

64. THE HOT SEAT, 2001

Eleven chromogenic prints,
5 x 7 in. each, 8½ x 80½ in. *(framed)*
Image: 5 x 77 in. Edition of 8
Collection of Themistocles and Dave Michos, San Francisco

**Death penalty, cinematic clichés,
and the porno of capital punishment.**

TOP
CONDEMNED, 2000
Four gelatin silver prints
Checklist #53

BOTTOM
BUCKLE UP, 2000
Fourteen chromogenic prints
Checklist #51

65. SHUT UP, 2001
Chromogenic print,
30 x 40 in., 36½ x 46½ in. *(framed)*
Image: 30 x 40 in. Edition of 8
Courtesy of American Fine Arts, Co./
Colin de Land Fine Art, New York

**For the office wall
of a powerful woman executive.**

66. BIRTH CONTROL, 2003
Eighteen chromogenic prints,
5 x 7 in. each. 1st section: 8½ x 99¾ in.;
2nd section: 8½ x 29 in. *(framed)*
Image: 5 x 98 in. (1st section); 5 x 28 in. (2nd section)
Edition of 8
Courtesy of Dianne Elise Strauss,
Portfolio Group, Santa Fe

**Movie stars! Doctors! Nurses! Push!
The miracle of birth can end so badly.**

67. BLACK AND WHITE CURTAINS, 2003
Seven chromogenic prints,
5 x 7 in. each, 11½ x 55½ in. *(framed)*
Image: 5 x 49 in. Edition of 8
Collection of Harvey S. Shipley Miller

Everyone deserves their own stage.

68. HAIR IN THE GATE, 2003
Durst Lambda digital prints,
8¼ x 12 in. each, 14⅞ x 90½ in. *(framed)*
Image: 8¼ x 84 in. Edition of 8
Collection of Harvey S. Shipley Miller

**"Money" shots of big-budget epics
ruined by careless camera crew—
someone would be so fired!**

69. LAST CALL, 2003
Eight chromogenic prints,
3½ x 5 in. each, 7 x 43½ in. *(framed)*
Image: 3½ x 40 in. Edition of 8
Courtesy of American Fine Arts, Co./
Colin de Land Fine Art, New York

**An alcoholic's daily fear—
zero in on sobriety.**

70. MANSON COPIES BRAD PITT, 2003
Two chromogenic prints,
5 x 7 in. each, 8½ x 17½ in. *(framed)*
Image: 5 x 14 in. Edition of 8
Collection of Vincent and Shelly Fremont

**A snipe hunt. Find same framing.
Same type glasses. Same look. Manson knows
he's more famous.**

71. PYRO, 2003
Eleven chromogenic prints,
5 x 7 in. each, 8½ x 80½ in. *(framed)*
Image: 5 x 77 in. Edition of 8
Courtesy of Arthur Roger Gallery, New Orleans

**A rewritten, re-edited, and redirected
narrative that was never there in the first
place. Now I have final cut!**

72. RETURN TO SENDER, 2003
Durst Lambda digital print,
47 x 30 in., 53½ x 36 in. *(framed)*
Image: 47 x 30 in. Edition of 8
Collection of Harvey S. Shipley Miller

**The mailman is tricked into
drawing and writing for my art enjoyment.**

73. TEN CHANGE-OVER MARKS, 2003
Ten chromogenic print cut-outs,
6½ x 40 in., 9½ x 43 in. *(framed)*
Image: 6½ x 40 in. Edition of 8
Collection of the Judith Rothschild Foundation

**Nothing carved, punched, or scratched
into celluloid should go unnoticed.**

74. 308 DAYS, 2003
Durst Lambda digital print,
48½ x 116 in. *(framed)*
Image: 42 x 110 in. Edition of 4
Courtesy of American Fine Arts, Co./
Colin de Land Fine Art, New York

**Exhausting. Make a list. Check it twice.
Do something! Get busy!**

75. WICKED GLINDA, 2003
Chromogenic print,
16 x 24 in., 22½ x 30½ in. *(framed)*
Image: 16 x 24 in. Edition of 8
Collection of Patricia Gidwitz

**The Good Witch and the Bad Witch morph
into the ultimate screen heroine.**

76. WRITER'S BLOCK, 2003
Six chromogenic prints,
5 x 7 in. each, 11½ x 48½ in. *(framed)*
Image: 5 x 42 in. Edition of 8
Collection of Tama Janowitz and Timothy Hunt

**A color everybody's seen but never noticed
can stop you in your tracks.**

SCULPTURE

77. SECRET MOVIE, 2000
Chromogenic print on pedestal
Pedestal: 6 x 7 x 108 in.
Image: 3½ x 5 in. (three images to be interchanged)
Edition of 4
Courtesy of Rena Bransten Gallery, San Francisco

A movie title so undiscovered,
so ironically beautiful that I can never share
it with the outside world.

78. JACKIE COPIES DIVINE'S LOOK, 2001
Doll on pedestal with glass dome, Doll: 15⅛ in. tall
Pedestal: 30¾ x 13¾ x 13¾ in.; dome: 10 x 20 in.
Edition of 4
Courtesy of Rena Bransten Gallery, San Francisco

Jackie visits *Pink Flamingos*
and still looks elegant.

79. SNEAKY JFK, 2001
Doll on pedestal with glass dome, Doll: 16⅛ in. tall
Pedestal: 30¾ x 13¾ x 13¾ in.; dome: 10 x 20 in.
Edition of 4
Courtesy of Rena Bransten Gallery, San Francisco

Maybe once, JFK was so jealous
of Jackie's fame that he snuck into her closet
and put on her look and felt so stupid
he never did it again.

80. FLOP, 2003
Needlepoint pillow on pedestal
16 x 26 in.
Edition of 4
Courtesy of Dianne Elise Strauss, Portfolio Group, Santa Fe

Celebrity box office shame—
old money style.

81. FUNNY FACE, 2003
Photocopied drawing on plywood, metal chain
surrounded by aluminum casting with Plexiglas top
18 in. diam. x 4 in. casting, ¼ in. Plexiglas top
Edition of 5
Courtesy of American Fine Arts, Co./
Colin de Land Fine Art, New York

John Waters as a toy; a parent's concern.

EARLY FILMS

82. HAG IN A BLACK LEATHER JACKET, 1964
8mm, black and white, 17 min.
Courtesy Dreamland Studios

When I thought film editing
magically happened by itself inside
the camera.

83. ROMAN CANDLES, 1966
Three 8mm reels shown simultaneously,
color and black and white, 40 min.
Courtesy Dreamland Studios

Home movies in Baltimore;
early, early Dreamland.
"Let's put on a fucked-up show!"

84. EAT YOUR MAKEUP, 1967
16mm, black and white, 45 min.
Courtesy Dreamland Studios

Theatre of the Absurd;
all shot on my parents' front lawn.

EPHEMERA

Selected objects—displayed in a context room designed
by Vince Peranio to reflect John Waters's working process
and sensibility—include: posters, movie props, marketing,
and publicity items from Waters's films; selected clippings
from Waters's scrapbooks, notebooks, and bulletin boards;
souvenir and merchandising items from television shows
and movies collected by Waters; magazines and publica-
tions that reflect Waters's eclectic influences and interests;
framed photographs, historical, religious, and popular cul-
tural memorabilia from Waters's home and studio.

Ephemera items are courtesy of the Wesleyan University
Cinema Archives and John Waters.

BUCKLE UP

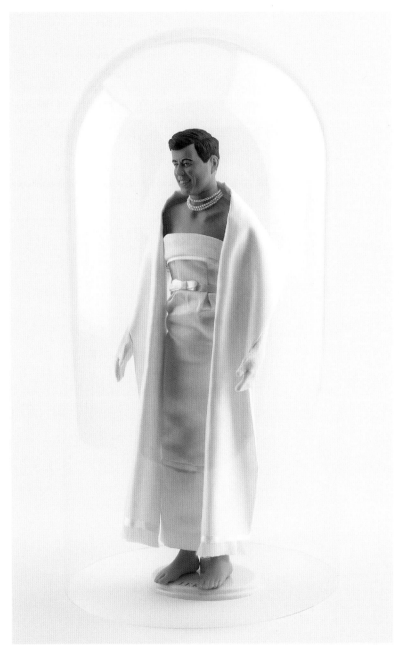

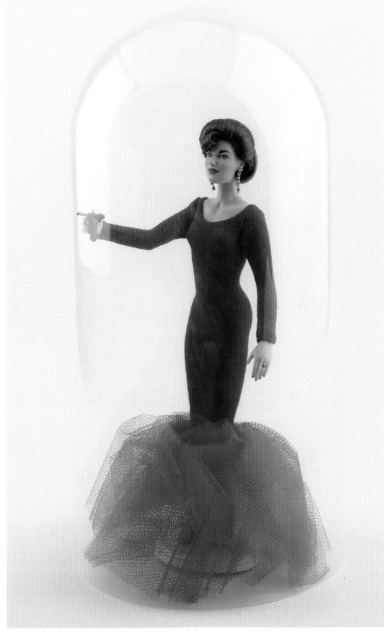

LEFT
SNEAKY JFK, *2001*
Doll on pedestal with glass dome
Checklist #79

RIGHT
JACKIE COPIES DIVINE'S LOOK, *2001*
Doll on pedestal with glass dome
Checklist #78

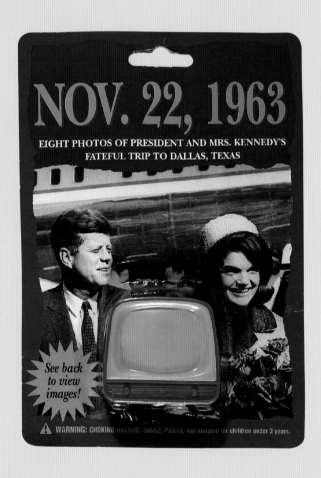

Souvenir and book from the personal collection of John Waters

TOP
Pope candle from the personal collection
of John Waters

RIGHT
1967 cover story in *The Realist* magazine
by Paul Krassner from the personal
collection of John Waters

BOTTOM
Three-dimensional anatomically correct
model of a human heart from the personal
collection of John Waters

FUNNY FACE, 2003
Photocopied drawing on plywood and metal chain
surrounded by aluminum casting with Plexiglas top
Checklist #81

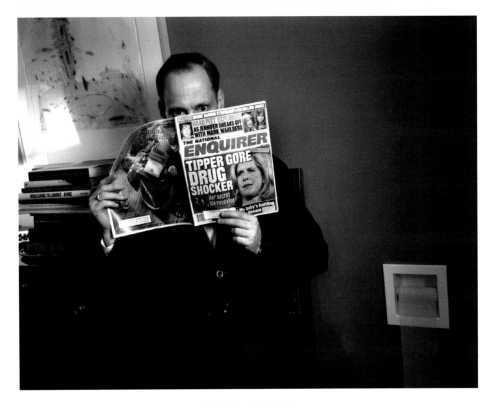

JOHN WATERS

Born 1946
Lives and works in Baltimore, Maryland

SELECTED ONE-PERSON EXHIBITIONS

2003
Flop, Rena Bransten Gallery, San Francisco, CA
Hair in the Gate, Portfolio Group-Salon
 Privé, Santa Fe, NM
Hair in the Gate, Albert Mereola Gallery,
 Provincetown, MA
Hair in the Gate, American Fine Arts, Co.,
 New York, NY

2002
Galleria Emi Fontana, Milan, Italy
Arthur Roger Gallery, New Orleans, LA

2001
Galerie Emmanuel Perrotin, Paris, France

2000
*A Two Year Old Choked to Death Today on
 an Easter Egg*, Hallway, London, UK
*A Two Year Old Choked to Death Today on an
 Easter Egg*, Albert Mereola Gallery,
 Provincetown, MA
*A Two Year Old Choked to Death Today on an
 Easter Egg*, Georg Kargl Gallery, Vienna, Austria
John Waters, Arthur Roger Gallery,
 New Orleans, LA
Straight to Video, American Fine Arts, Co.,
 New York, NY
Straight to Video, C. Grimaldis Gallery,
 Baltimore, MD
Straight to Video, Greg Kucera Gallery,
 Seattle, WA

1999
John Waters: Photographs, Wexner Center for the
 Arts, Columbus, OH

1998
Low Definition, American Fine Arts, Co.,
 New York, NY
Low Definition, Albert Mereola Gallery,
 Provincetown, MA
Low Definition, Parco Gallery, Tokyo, Japan
Marks, Gavin Brown's Enterprise, New York, NY

1996
Director's Cut, American Fine Arts, Co.,
 New York, NY
Director's Cut, Pace Wildenstein MacGill,
 Los Angeles, CA
Director's Cut, Arthur Roger Gallery,
 New Orleans, LA
Director's Cut, Galleria Emi Fontana, Milan, Italy
Director's Cut, Galerie Emmanuel Perrotin,
 Paris, France

1995
My Little Movies, American Fine Arts, Co.,
 New York, NY
My Little Movies, Galerie Christian Nagel, Cologne,
 Germany
My Little Movies, Aeroplastics Contemporary,
 Brussels, Belgium

SELECTED GROUP EXHIBITIONS

2003
Twentieth Anniversary Exhibition, Gavin Brown's
Enterprise, New York, NY

2002
Art Downtown: New Photography,
25 Broad Street, New York, NY
Enough About Me, Momenta Art, Brooklyn, NY
Hair Stories, Adam Baumgold Gallery,
New York, NY
Screen Memories, Contemporary Art Center,
Art Tower Mito, Tokyo, Japan
Sans Consentment, CAN-Centre d'Art Neuchâtel,
Neuchâtel, Switzerland
Something, Anything, Matthew Marks Gallery,
New York, NY

2001
Boomerang, Exit Art, New York, NY
American Fine Arts, Co. at Pat Hearn,
New York, NY
Galeria Marta Cervera, Madrid, Spain
Albert Mereola Gallery, Provincetown, MA
Skank, Plus Ultra, Brooklyn, NY

1999
*Focus: Photographs by Painters, Sculptors,
and a Filmmaker*, Thomas Segal Gallery,
Baltimore, MD

1998
GhostStory, Kunstlerhaus, Vienna, Austria
Peep Show, Vankin Schwartz, Atlanta, GA
Pop-Surrealism, The Aldrich Museum
of Contemporary Art, Ridgefield, CT
When Worlds Collide, Center for Contemporary
Art, Glasgow, Scotland

1997
Biennale de Lyon, Lyon, France
Essence d'un Sens (Sentir du Regard),
Passage de Retz, Paris, France
Photo-Op, Cincinnati Contemporary Art Center,
Cincinnati, OH
Someone Else with My Fingerprints,
David Zwirner, New York, NY

1996
Art at Home, Ideal Standard Life,
Spiral Garden 1F, Tokyo, Japan

1995
Summer Group Show, American Fine Arts Co.,
New York, NY

FILMOGRAPHY

2004
A Dirty Shame

2000
Cecil B. DeMented
35mm, color, 87 minutes

1998
Pecker
35mm, color, 87 minutes

1994
Serial Mom
35mm, color, 95 minutes

1990
Cry-Baby
35mm, color, 85 minutes

1988
Hairspray
35mm, color, 92 minutes

1981
Polyester
35mm, color, 86 minutes

1977
Desperate Living
16 & 35mm, color, 90 minutes

1974
Female Trouble
16mm, color, 89 minutes

1972
Pink Flamingos
16 & 35mm, color, 93 minutes

1970
Multiple Maniacs
16mm, black and white, 90 minutes

1969
The Diane Linkletter Story
16mm, black and white, 10 minutes
Mondo Trasho
16mm, black and white, 95 minutes

1967
Eat Your Makeup
16mm, black and white, 45 minutes

1966
Roman Candles
three 8mm reels shown vertically,
color and black and white, 40 minutes

1964
Hag in a Black Leather Jacket
8mm, black and white, 17 minutes

FILMS ABOUT THE ARTIST

1999
Yeager, Steve. *In Bad Taste: The John
Waters Story*. Jericho, NY: Independent
Film Channel.

1998
Yeager, Steve. *Divine Trash*. New York:
Stratosphere Entertainment.

SELECTED BIBLIOGRAPHY

2003
Saltz, Jerry. "At the Movies with John Waters: Film
Comment." *Village Voice*, March 19–25, 59.

2002
Giuliano, Mike. "Must-See TV." *Baltimore City
Paper*, November 6.
Stoilas, Helen. "John Waters, Straight."
Art & Auction (January).

2001
Cotter, Holland. "Skank." *New York Times*,
June 1.
Finlay, Karen, ed. *Aroused: A Collection of Erotic
Writing*. New York: Thunder's Mouth Press.
"Whatever Happened to Showmanship?" *Literatur
Beaux-Arts Filosofia* (February): 72–73.

2000

"John Waters." *New Yorker*, December 11, 30.

"John Waters." *Village Voice,* December 12, 105.

Landman Krel, Beth, and Ian Spiegelman. "Chambers Runs Waters's Stills." *New York Magazine,* August 21, 9.

Newhall, Edith. "Still Waters." *New York Magazine,* December 4, 131.

Wehr, Anne. "Pretty Ugly Woman." *Time Out,* November 16.

1999

McCormick, Carlo. "Confessions of a Movie Star Junkie." *Juxtapoz,* no. 19 (March/April): 37, 72.

Wilson Lloyd, Ann. "An Arts Colony Turns Up the Esthetics for Its 100th." *New York Times,* June 13, sec. 2, 38.

1998

De Koff, Derek. "Mondo Pride." *Next Magazine,* June 19.

Eldredge, Richard. "Director Tests Waters with Show." *Buzzweekly,* January 16, sec. F, 2.

Hoberman, J. "Director's Cut." *Bookforum* (Spring).

"John Waters." *New Yorker*, November 11.

"John Waters." *Village Voice,* December 1.

Norwich, William. "Style Diary." *New York Observer,* July 13.

Subotnick, Ali. "Watermarks." *ARTNews* (September).

Thill, Robert. "The Only Thing in a Movie Scene That You Are Not Supposed to See." *Transcript* 3, no. 3 (June).

Yablonksi, Linda. "John Waters, Marks." *Time Out,* July 16–23.

1997

De Land, Colin. "A Conversation with John Waters." *Parkett,* no. 49: 6–25.

Frank, Peter. "Art Picks of the Week: Dennis Hopper, John Waters," *LA Weekly,* July 11–17.

Goldin, Nan. "The Best of 1996." *Village Voice,* January 7.

Halley, Peter, and Bobo Nickas. "John Waters." *Index* (January): 7–16.

"John Waters." *Buzzweekly,* July 18–22.

Kandel, Susan. "'Water' Proves to Be a Slippery Subject." *Los Angeles Times,* June 27, 22.

Rian, Jeff. "Biennale de Lyon, The Other." *Flash Art* 30, no. 196 (October): 94–95.

Shelley, Jim. "Divine Madness." *Guardian Weekend,* November 8, 31–36.

Turner, Grady. "John Waters at American Fine Arts." *Art in America* 85, no. 3 (March): 100.

1996

Halle, Howard. "John Waters, Director's Cut." *Time Out,* November 28.

Pedersen, Victoria. "Art: The World According to John Waters." *Paper Magazine,* Internet site (November).

Stevenson, Jack. *Desperate Visions 1: Camp America, the Films of John Waters and George & Mike Kuchar.* London: Creation Books.

1995

Aletti. "Photo." *Village Voice,* May 9, 66.

Hainley, Bruce. "John Waters." *Artforum* 34, no. 1 (September): 89–90.

1992

Ives, John G. *John Waters.* New York: Thunder's Mouth Press.

PUBLICATIONS BY THE ARTIST

2003

Art: A Sex Book. Co-written with Bruce Hainley. New York and London: Thames and Hudson.

Crackpot: The Obsessions of John Waters. Revised and expanded edition. New York: Scribner.

1999

Twelve Assholes and a Dirty Foot. Toronto: Little Cockroaches Press.

1997

Director's Cut. Zurich and New York: Scalo.

1988

Trash Trio: Three Screenplays. New York: Vintage Books.

1986

Crackpot: The Obsessions of John Waters. New York: Macmillan; London: Collier Macmillan.

1981

Shock Value: A Tasteful Book About Bad Taste. New York: Dell Publishing Company.

PIMPLES, 1998
Eight chromogenic prints
Checklist #44

Still from
PINK FLAMINGOS,
1972

The New Museum gratefully acknowledges permission
to reproduce copyright material in this book. Every effort has been made
to trace and contact copyright holders of materials used in
JOHN WATERS: CHANGE OF LIFE.

All photographs of John Waters's work by Jason Mandella, except cover image,
Twelve Assholes and a Dirty Foot, *Jackie Copies Divine's Look*, and *Sneaky JFK* by Ian Reeves, and *Secret Movie*
courtesy of American Fine Arts, Co./Colin de Land Fine Art, New York.
Ephemera by David Penney.

PHOTO CREDITS

P. 8 left: courtesy of Juggy Murray, Chairman, Sue Records Entertainment; p. 8 right: AP/Wide World Photos. Courtesy of Enslow Publishers, Inc.; p. 9 top: Use of front page banner courtesy of The Baltimore Chronicle; p. 9 left: Courtesy of Eva Tremila; p. 9 right: © New York Daily News, L.P. reprinted with permission; p. 18 left: TM 2003 Jayne Mansfield by CMG Worldwide, Inc. www.CMGWorldwide.com; p. 18 right: Courtesy of the Archives of the Catholic Diocese of Rochester; p. 19 top left: Courtesy of the Liberace Foundation for the Performing and Creative Arts; p. 20 top, left, right: Courtesy of New Line Productions. Photo by Michael Ginsberg; p. 22 right: Courtesy of New Line Productions. Photos by Chuck Shacochis; p. 26 right: Courtesy of Steve Yeager; p. 38 top: Courtesy of Bruce Silverstein Gallery; p. 38 bottom: Courtesy of Gagosian Gallery. ©2003 Andy Warhol Foundation for the Visual Arts/ARS, New York; p. 40 bottom: Courtesy of Barbara Gladstone; p. 49 left: ©1967 SEPS: Licensed by Curtis Publishing, Indianapolis, IN. All rights reserved. www.curtispublishing.com; p. 51: Courtesy of HeroBuilder.com; p. 52 top: Time Life Pictures/Getty Images; p. 52 bottom: Courtesy of New Line Productions. Photo by Steve Yeager; p. 53 top: Courtesy of New Line Productions. Photo by Lawrence Irvine; p. 53 center: ©1994 Savoy Pictures. Photo by Phillip V. Caruso; p. 53 bottom: Courtesy of Artisan Entertainment. Photo by Abbott Genser; p. 54 center, bottom: Courtesy of New Line Productions. Photo by Steve Yeager; p. 61 left: Courtesy of New Line Productions. Photo by Henny Garfunkel; p. 61 right: Courtesy of New Line Productions. Photo by Michael Ginsberg; p. 62 left: Courtesy of New Line Productions. Photo by Larry Dean; p. 62 right: ©1990 Universal City Studios, Inc. and Imagine Films Entertainment, Inc. Photo by Henny Garfunkel; p. 65 top, bottom: Courtesy of New Line Productions. Photo by Michael Ginsberg; p. 70: Courtesy of the National Enquirer; p. 73 top left: Courtesy of Oli Watts; p. 73 bottom right: Courtesy of the National Enquirer; p. 74 top left: Courtesy of Liz Renay; p. 74 top right: Courtesy of Lawrence Erlbaum Associates, Inc., Publishers. Cover design by Carolyn Kinsman.; p. 74 bottom left: Courtesy of Penguin (USA); p. 75 top left: *Why Catholics Can't Sing: The Culture of Catholicism and The Triumph of Bad Taste* by Thomas Day. ©1992 Courtesy of The Crossroad Publishing Company; p. 75 bottom left: Courtesy of Schneidereith & Sons; p. 83: Courtesy of the artist and Sonnabend Gallery; p. 88 left, right: ©2003 Sol LeWitt/Artists Rights Society (ARS), New York; p. 90 left: Digital image ©The Museum of Modern Art, New York. ©2003 Artists Rights Society (ARS), New York/VG Bild-Kunst, Bonn; p. 90 right: The Museum of Fine Arts, Boston; p. 92: Private Collection, USA. Courtesy of Zwirner and Wirth, New York; p. 95: Courtesy of American Fine Arts, Co./Colin de Land Fine Art, New York; p. 101 left: ©1982 Newsweek, Inc. All rights reserved. Reprinted with permission; p. 106; Courtesy of American Fine Arts, Co./Colin de Land Fine Art, New York; pp. 118-123: Courtesy Dreamland Productions; p. 137 right: Courtesy of Paul Krassner. Cover illustration Ed Sorel; p. 140: Photo by Jeannette Montgomery Barron; p. 144: Courtesy of New Line Productions. Photo by Lawrence Irvine.

LIBRARY OF CONGRESS CATALOGING-IN-PUBLICATION DATA

Waters, John, 1946–
John Waters: change of life / exhibition co-curated
by Marvin Heiferman and Lisa Phillips;
with contributions by Marvin Heiferman...[et al.].
p. cm.
Includes bibliographical references and index.
ISBN 0–8109–4306–9
1. Photography, Artistic—Exhibitions.
2. Stills (Motion pictures)—Exhibitions.
3. Waters, John, 1946—Exhibitions.
4. Waters, John, 1946—Notebooks,
sketchbooks, etc.—Exhibitions.
I. Title: Change of life. II. Heiferman, Marvin.
III. Phillips, Lisa. IV. New Museum of Contemporary
Art (New York, N.Y.) V. Title.

TR647.W36778 2004
779'.092—dc22

2003020889

Production manager
MELANIE FRANKLIN

Graphic design
LORRAINE WILD AND STUART SMITH

Editor
MICHELLE PIRANIO